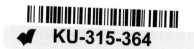

Contents

Is it about answers at all? I don't think so. More important than answers is the discussion born in the moment, that people should have their eyes open to see what is alive in the present moment.

5 Introduction

8 Annika Ekdahl (Sweden)

18 Inger-Johanne Brautaset (Norway)

28 Marianne Mannsaaker (Norway)

38 Astrid Krogh (Denmark)

48 Aino Kajaniemi (Finland)

58 Ane Henriksen (Denmark)

68 Anna Lindal (Iceland)

78 Hildur Bjarnadottir (Iceland)

88 Piila Saksela (Finland)

98 Wagle & Lovaas (Norway)

108 Gunvor Nervold Antonsen (Norway)

118 Ulla-Maija Vikman (Finland)

You have just to listen to the voice, what you should do next. What would be the proper act right now.

this page:

Gunvor Nervold Antonsen

Textured Rooms

2001

embroidery and projection

variable dimensions

page 5:

Astrid Krogh

Holbein (detail)

2002

neon tapestry

200 x 320cm

page 6:

from left to right: **Naomi Koba-
yashi, Harri Leppanen, Inger-
Johanne Brautaset**

1998

From Rijswijk Museum,

The 2nd Holland Paper Biennial

Art Textiles of the World
SCANDINAVIA

volume 1

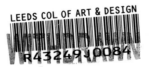

© Telos Art Publishing
1, Highland Square
Clifton, Bristol
BS8 2YB
England
T/F +44 (0)117 923 9124
editorial@telos.net
www.arttextiles.com

Edited by Matthew Koumis
Copy-Editor & Proof Reader: Rosie Tatham
Graphic Design by Katharina Riegler, Italy
Reprographics by Typoplus, Frangart (BZ), Italy
Printed by Commerciale Borgogno, Bolzano, Italy

First printed in Italy November 2004

ISBN 1 902015 01 0

A CIP catalogue record for this book is available form the British Library

The four Norwegian artists wish to acknowledge support from the Arts Council, Norway.

Photo credits

Ole Akhoj, Anders Berg, Axel Sogaard, Guldager Fotografi, Karen Ahrenkilde, Lena Benstsson, Heikki Tuuli, Geir S. Johannessen, Thor Westrebo, Gudrun Gunnarsdottir, Espen Tollefsen, H. Haugerud, O. Vaering, L. Watson, Helgi Braga, Benedikt Kristthorsson, Ivar Brynjolfsson, Spessi, Marjaana Kella, Esko Koskenranta, Rauno Trjäskelin, Ivar Brynjolfsson, Kristin Hauksdottir, Yalcin Erhan, Riitta Järelä, Rauno Träskelin.

Editor's Acknowledgements

This book is dedicated to my Mother and Father, with all my love.
There is not room to thank the many people across Europe who have kindly recommended artists to me, it is very much appreciated. Thanks in particular to Alison McFarlane, Paul Richardson, Christopher Springham, Hector Peebles, Kristiina Hanninen, Katharina Riegler, Susan Lordi Marker and Dennis Marker, Typoplus, Luca Borgogno, Poppy, Tamsin and Maia Koumis. Texts on the contents page seen at Kiasma, Helsinki, by artists Markus Konttines (top) and Teuri Haarla (bottom).

Notes

All dimensions are shown height x width x depth.
All biographies have been edited to a consistent length and are *selections* only.

2

A Gentle Geometry

Art textiles in the 21st century are a mode of vision, a way of seeing the world, more than a question of what is made or how it is made. This vision is often instinctively infused with love and poetry. In the work of Scandinavian textile artists, certain preoccupations recur: a feel for the open spaces of nature and a yearning for light; traditional techniques, embraced, transcended or flouted; a stylistic flair for linear geometry of great elegance; a sometimes crushing sense of social isolation; a feel for modern technologies; and a dynamic involvement with the architectural setting.

In the work of Anna Lindal from Iceland, geography meets art. Star constellations, the smoke emanating from erupting lava, the patterns of rock strata, their patterning and their randomness are mysteriously but convincingly translated into compelling video installations. The natural world is also celebrated by Norwegian paper artist Inger-Johanne Brautaset, in particular the changing moods of the sea. "The studio ceiling catches the sea's sparkle, flickering on the walls, or being caught by the wet paper pulp in its tubs; glints of colours."

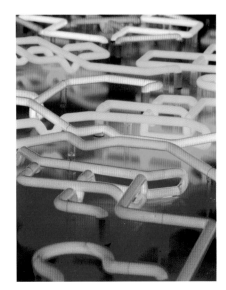

The work of Finnish artist Ulla-Maija Vikman shares with Brautaset an aesthetic purity, a direct translation of nature into art. The cascading, painted threads convey a gentle vision of landscape in the subtle hues of Nordic light. Quivering in the wind, her hangings come to life in their ambient space.

Weaving is given a contemporary twist by Swedish artist Annika Ekdahl. Exploiting the close connections between pixellated digital technique and the woven surface, and working from designs which she has manipulated in Photoshop, she creates tapestries of epic proportion and filmic, contemporary nature.

The Danish artist Ane Henriksen subverts the traditional woven surface by introducing rubber protrusions; resembling Braille, they articulate a code of expression for an inner winterland. For Norwegian artist Marianne Mannsaaker, her encounter with Berber culture has been significant. "The word for the bottom bar of the loom can also mean 'of earth', while that for the upper bar means 'of heaven'. Thus the tapestry can be said to connect earth and heaven." How interesting it would be to compare the depiction of landscape in the work of Mannsaaker and Henriksen with that of Aboriginal batik artists: codified representations of the land, a mystical sense of human traces; but what a different natural landscape, palette and world view!

Iceland's Hildur Bjarnadottir consciously rebels against a craft tradition. Combining virtuoso hands with an acerbic visual wit, her works may often be small in realisation but will resonate in the imagination of the viewer for a long time.

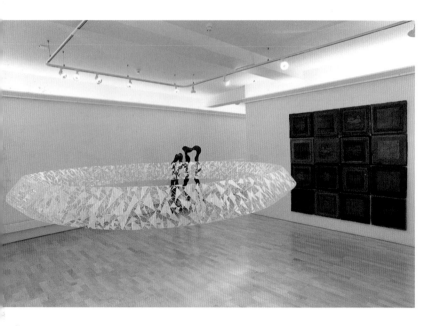

Few figurative textile artists anywhere in the world depict the human face with such poignancy as Finnish weaver Aino Kajaniemi. She writes "Lonely working and the possibility of meeting somebody through my works. I use old and difficult techniques. In a way it resembles ballet, where the dance seems easy and light as a feather, but in reality the training and sheer effort is as heavy as lead".

The Norwegian artist Gunvor Nervold Antonsen breaks silence by composing texts, embroidering them, projecting fragments using a slide projector on top of her multi-layered hangings. The resulting installations convey both a desire for, and a fear of, human communication and interaction. As she stands with her face covered by projected images of horizontal threads, is she being crucified by the weft, or humanising it?

A gentle geometry characterises the work of esteemed Finnish artist Piila Saksela. Her hangings recall a Japanese aesthetic, and convey both her desire to harness light and to express

'fortuity', allowing of happy accidents in the creative process. Collaborations between textile artists and architects reflect the beneficent economic conditions which periodically shine over this part of Europe. Copenhagen-based textile designer Ingrid Krogh, recipient of prestigious commissions including the Danish Parliament House, works predominantly with what can be described as neon wallpaper; while Oslo based textile artists Wagle & Lovaas are collaborating on the new national Opera House of Oslo with architects Snohetta. Krogh and Wagle & Lovaas' commissioned works provide fascinating examples of a modern system of art patronage as well as extending the textile mode of vision into other materials in a convincing way.

It is my hope that the reader of this modest book will find beauty, solace and inspiration within its pages. I have a recurring dream: to establish a pattern of regular, top-quality, touring exhibitions of outstanding contemporary textile art to the world's capital cities. With this book I hope to further this aim and thus to draw a wider public into the sphere of textile art.

If this civilisation were to pass away tonight, all the textile art in this book could not represent it. It is far too generous for that!

Matthew Koumis

Editor

Founder

Telos Art Publishing

Artists

1	Anna Lindal (Iceland)
	Hildur Bjarnadottir (Iceland)
2	Inger-Johanne Brautaset (Norway)
3	Gunvor Nervold Antonsen (Norway)
	Wagle & Lovaas (Norway)
4	Marianne Mannsaaker (Norway)
5	Ane Henriksen (Denmark)
	Astrid Krogh (Denmark)
6	Annika Ekdahl (Sweden)
7	Piila Saksela (Finland)
	Ulla-Maija Vikman (Finland)
8	Aino Kajaniemi (Finland)

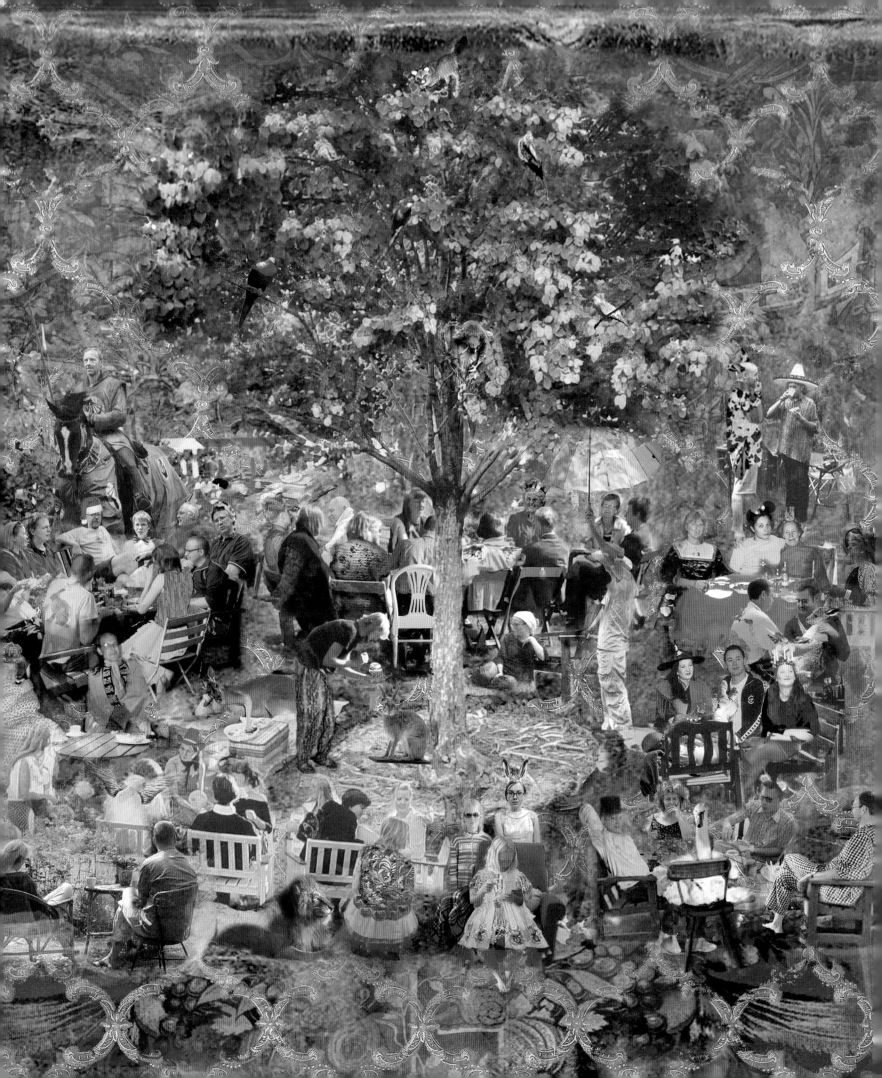

Annika Ekdahl

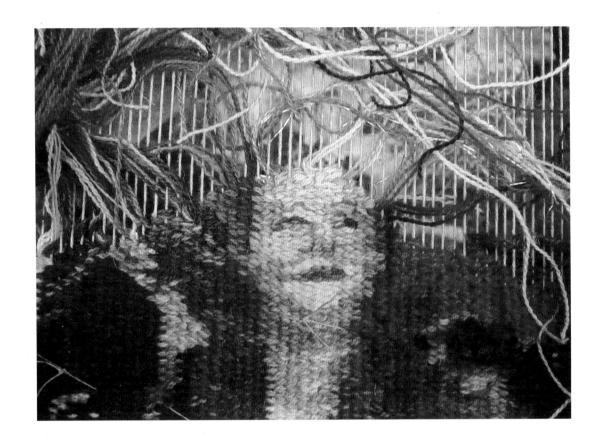

I've chosen an age-old technique for my storytelling, but my principal tool is my computer. There's a close connection between digital technique and the woven surface. I build up my picture with dots, pixels. So, I can vary every woven pixel, I can create any image I want.

left:
The Theatre in the Park
2004
Photoshop digital design
300 x 300cm

above:
The Theatre in the Park
(work in progress, detail)
tapestry
300 x 300cm

Some artists create in a traditional way – they draw, they paint, they etch – and then they use digital techniques to duplicate their work, or to translate it into other media through technology. I do things the other way round: I start things up digitally, and complete it in a well-tried technique, namely tapestry.

My work revolves around monumental, woven tapestry and I use its potential to recount contemporary stories – my stories. One of my inspirations is European, baroque and renaissance tapestry. These masterpieces show little humility; they display the creator's skill on a vast scale, and shamelessly consume time and space. They are expert storytellers and I aim to attain something of their special atmosphere.

I've chosen an age-old technique for my storytelling, but my principal tool is my computer. There's a close connection between digital technique and the woven surface. I build up my picture with dots, pixels. So, I can vary every woven pixel, I can create any image I want.

I collect digital photos, I scan photos and I scan things I've painted. Or sometimes I scan things I've found, pieces of paper, a bit of fabric or maybe a detail from another tapestry. In Photoshop I put them all together, change the scale of certain details, change colours and contrasts.

When I'm satisfied, I print it out. I always keep one smaller copy by the loom, to get an overview of the whole piece. I also have a full-scale print out under the warp – to help me with orientation while I weave.

I use an ordinary loom, with horizontal warp. Made in the 50s, it was used for making huge carpets for churches. I bought it ten years ago and it completely fills one room in my house like a ship that has run aground.

Things happen during the weaving process, the design may evolve and it's always both a terrible, and a wonderful moment when I take the piece out from the loom and see it for the first time!

I have worked in other techniques. I do a lot of painting, drawing and sometimes three-dimensional pieces. My most recent commission was a pink concrete sculpture, in cooperation with a colleague.

As far as weaving goes, I'm quick – it's probably an obsession! I believe that if you weave too slowly and too thoroughly, you risk the result becoming too 'proper and splendid.'

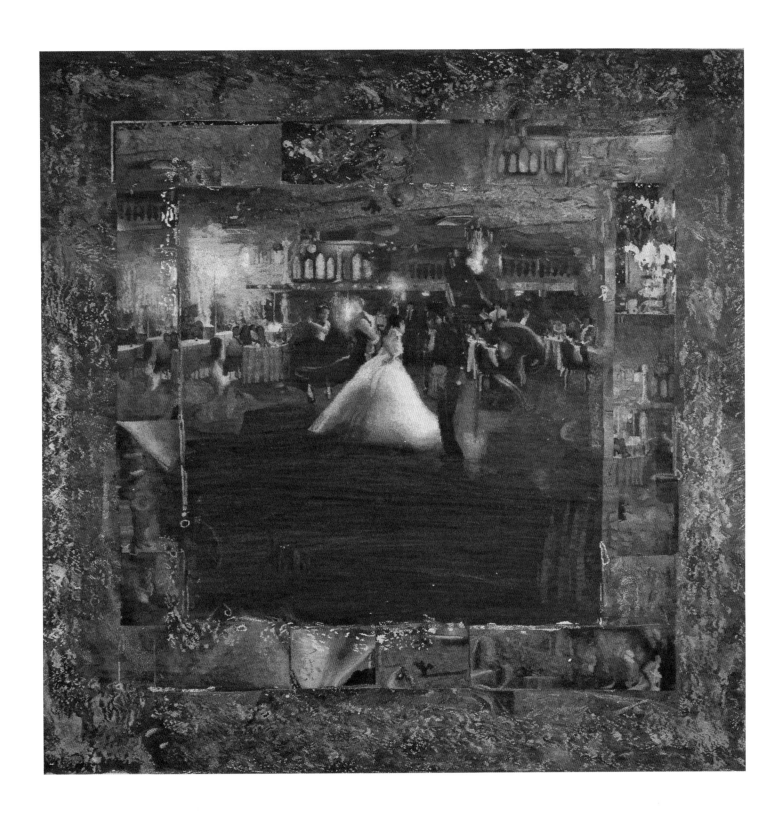

The Wedding at Queens
2002
tapestry
300 x 300cm

The title, *The Baroque Party,* refers to old, baroque tapestries – not to something odd or far out! It shows people gathered around a big, pink table. The people are my family: my son and his Mexican-American wife, her parents and brothers, my husband, myself, my two other sons, my father- and mother-in-law, my parents, my grand parents on both sides. They didn't get along very well in real life, but in my tapestry, my mother's mother has a great time with my father's father – they are tickling each other!

At the bottom of the table are some unidentified characters, with small wings on their backs. I do not exactly know who they are, but they were very anxious to be present at this baroque party.

In the middle of the table is an oversized cake, a Princess Cake. Every Swede knows Princess Cake, knows what it tastes like, remembers how, as kids, we all fought for the pink marzipan rose in the middle. My father-in-law, who was a minister, was very ascetic. So I gave him extremely big cutlery. There are many more such anecdotes in this tapestry, but it would take too long to tell them all.

For my most recent piece, *The Theatre in the Park,* I intend to do a black and white sketch explaining who everybody in the tapestry is. It's absolutely crowded with people, and I enjoy talking about them!

The Baroque Party
2000
tapestry
320 x 300cm

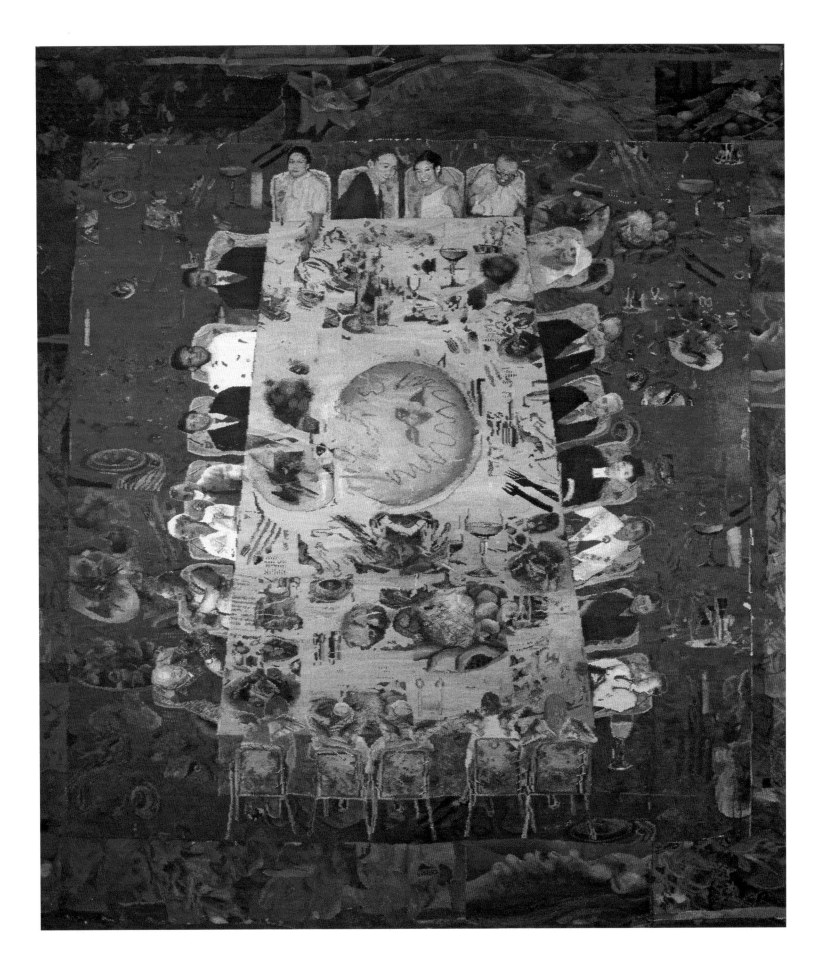

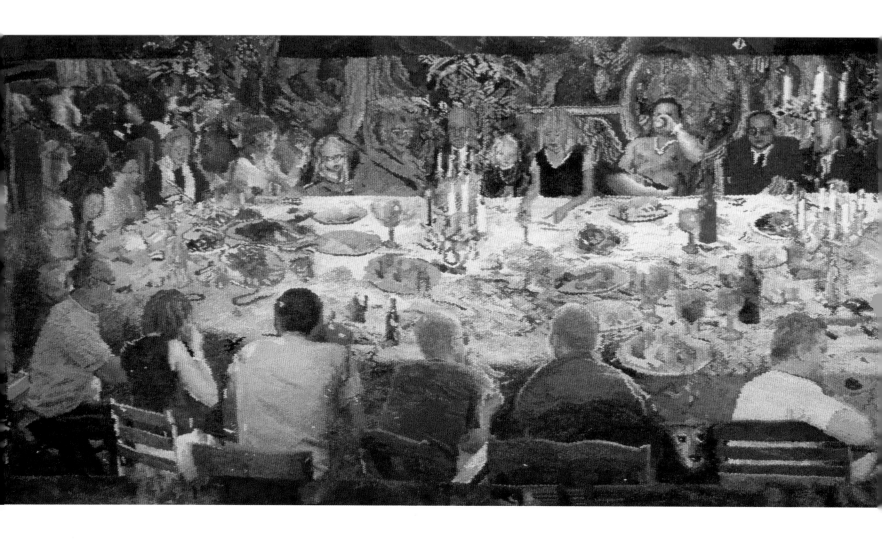

I dispute the theory that art making should be a quick business. Tapestry weaving is very time-consuming compared to baking a sponge cake, painting, or silkscreen printing, but not compared to writing a novel, making a movie, or bringing up a child.

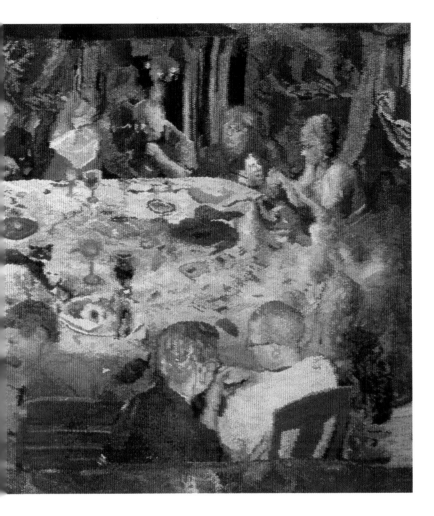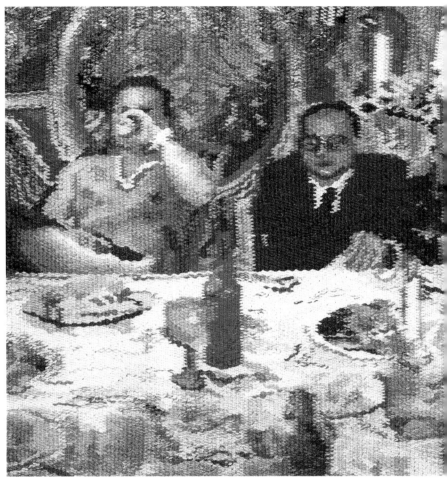

Darlings
2003
tapestry
100 x 300cm

'We're Fine' is a tablecloth. Or a scrawl board, a chatroom,

a guestbook or a social experiment. Or just a feel-good project.

We're Fine
2003
interactive embroidery
120 x 1000cm

Born 1955, Stockholm, Sweden
Atelier Kyrkhult, Sweden

Education and Awards
1989-94 MFA, University of Gothenburg, Sweden
1998 Honorary mention, Triennale of Tapestry, Lodz, Poland
2001 2nd prize, Karpit – International Tapestry Exhibition
 Museum of Fine Arts, Budapest
 Several national grants

Exhibitions
2004 Härsnösand Art Hall (solo), Sweden
 Kristianstad Museum (solo), Sweden
2003 Gallery Gröna Paletten (solo), Stockholm
2002 'Beijing 2002', China
 Rista Gallery (solo), Umea, Sweden
 'Thin Ice', University of Newcastle, Australia
2001 'Art of the stitch 2001', Mall Galleries, London
 Karpit – International Tapestry Exhibition, Budapest
 'Den nordiske tråd', Pakhuset, Nykøbing, Denmark
 Gallert Moment (solo), Ängelholm, Sweden
2000 'Beijing 2000', Tsinghua University, Beijing
1999 Museum of Applied and Decorative Art, Riga, Latvia
 Picture Gallery, Kaunas, Lithuania
 The Theatre Gallery, Kalmar
1998 Sintra Gallery, Gothenburg, Sweden
 Solvesborg Art Hall, Sweden

Commissions
 Various in tapestry, painting and sculpture for public spaces

Professional
2003 Board member, National Public Art Council
2002- Lecturer, Blekinge Institute of Technology
2000-2002 President, Fine Artist's Union

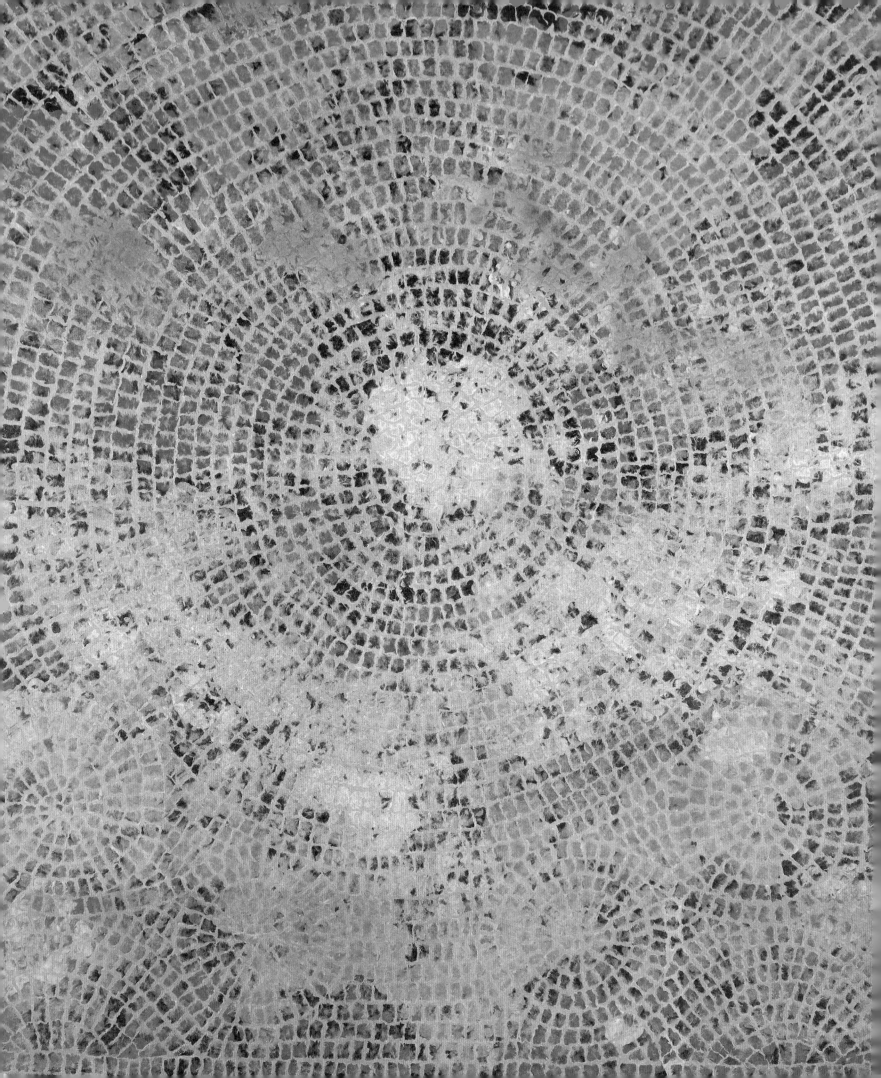

Inger-Johanne Brautaset

Drawing with paper. The great red and blue waves. The blue-green and white currents across the surface, the whirls. The life in the depths – the snail-shells, conches, the primitive forms of fish from millions of years ago lying undisturbed in the darkness at the bottom.

left:
Illusion III (detail)
2002
handmade paper,
pigments,
mixed technique
128 x 128cm

above:
Black Stripes with Dots
2004
handmade paper,
pigments, acrylic,
mixed technique
40 x 40cm

Quite early on in my education, I decided to concentrate on art. Ever since I was a child, I loved to draw, paint and design, to be creative with textile materials. The roots of my interest in textiles lie deep in my background. At home, the women in my family – my mother and both my grandmothers, are very creative with textiles, sewing and embroidering. My great-grandfather was a tailor and my father was a carpenter. So I had many creative influences around me in my childhood.

I started out as a tapestry weaver, and continued in this slightly traditional path for some 15 years. But, feeling rather constrained, I wanted increasingly to express myself in new ways, so I enrolled at The West Norway Academy of Fine Art in Bergen. At first I tried to combine tapestry with paper. I cast small fragments of tapestry into the paper pulp, but despite numerous experiments, nothing seemed to quite work.

One day, almost in desperation, I peeled off the woven tapestry fragment from the paper pulp. Seeing its imprint which was left on the dried paper, a new world was born for me in that moment [see *Stratum Black*, below]. The *Strata* sculptures, built up from many layers of paper sheets, followed on from those experiments which resulted in *Stratum Black*.

In recent years I have been concentrating on my two-dimensional pictures in hand-made paper. I make my own paper from Daphne, a plant native to Nepal, which I boil in caustic soda, and then rinse to obtain a pulp. At the outset, I will have a sheet of white paper, or paper which I have coloured with pigments. On this I make forms and figures in coloured pulp. Once the moisture has been drawn out, I add a third layer of damp pulp. By scraping away selected areas of paper from the upper layer, a picture gradually takes shape in the lower layers, while an additional pattern is formed by the untouched remains of the upper layer. Sometimes, the process may be less complicated: instead of making the second-layer figures and forms of coloured pulp, they may be painted in acrylic. The third layer is made in the same way as described above. Occasionally I may also paint with acrylic on the upper layer once the scraping process has come to an end.

above:
Strata Blue
1998
cast paper, pigments, plexiglass,
iron, mixed technique
165 x 40 x 40cm
156 x 18 x 37cm
160 x 40 x 35cm

right:
Stratum Black (detail)
1991
cast paper, pigments,
rag/fragments from tapestry
200 x 300 x 7cm

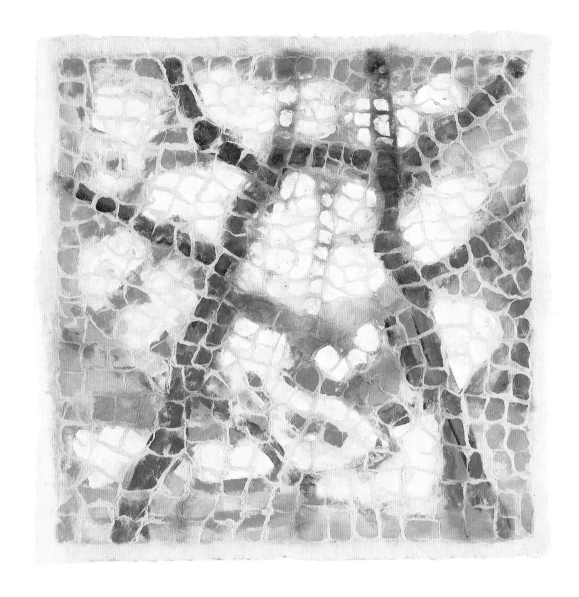

Memories of trekking in the mountains, of the glaciers where the ice has a distinctive beauty and rich colours in varying shades of turquoise and blue came to me.

The Room Between
2002
handmade paper, acrylic,
mixed technique
40 x 40cm

*Outside, below my window,
the sea is never at rest. Some-
times its surface may be calm,
yet there is always a swell,
ripples, a current, the regular
rhythm. At other times, waves
come hurrying along, or whirls,
maelstroms. But mostly there
are only small waves reflecting
the sky, the sun.*

Whirls
2000
 handmade paper, pigments,
mixed technique
155 x 155cm

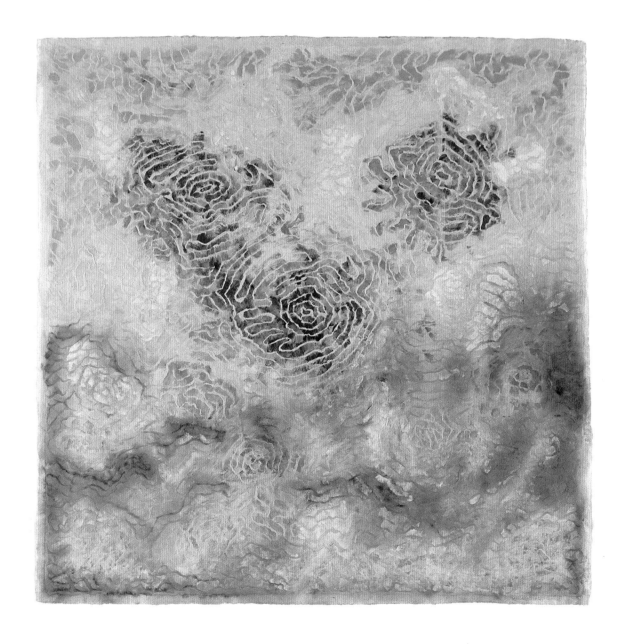

above:
Translucency I
2002
handmade paper, pigments,
acrylic
83 x 83cm

right:
Shimmer
2002
handmade paper, acrylic,
pigments, mixed technique
128 x 128cm

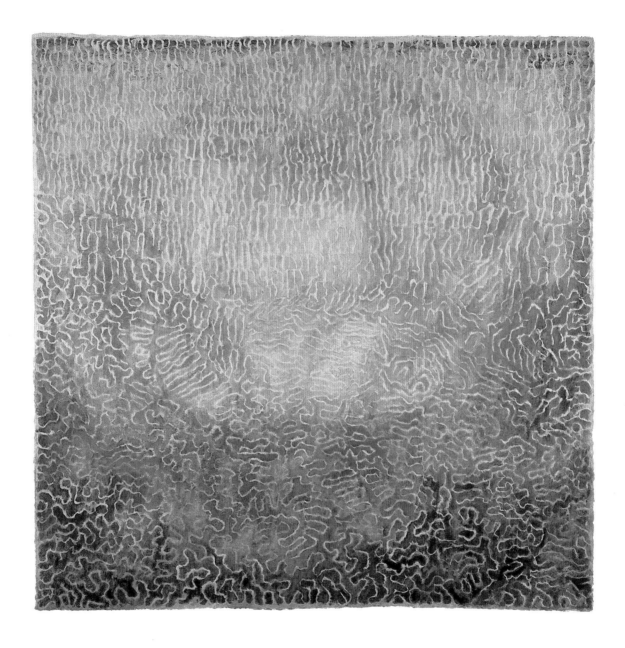

On the surface the sea is always in motion, alternating between its structured and its floating compositions.

Inger-Johanne Brautaset

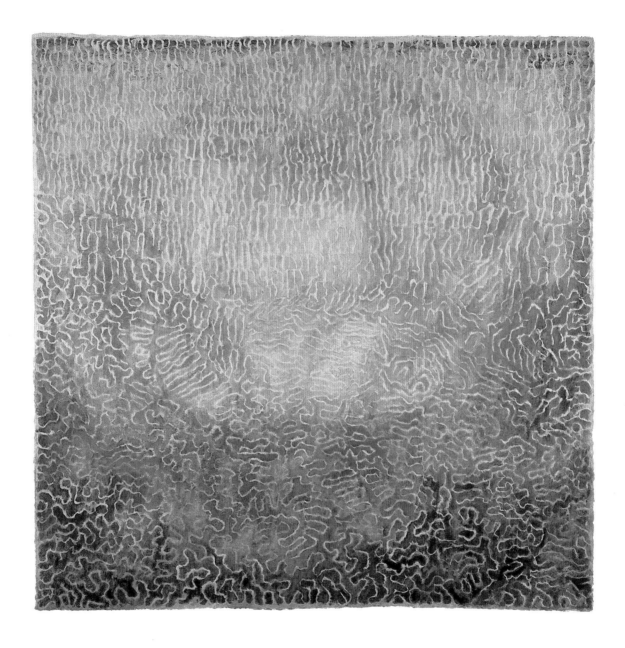

On the surface the sea is always in motion, alternating between its structured and its floating compositions.

25

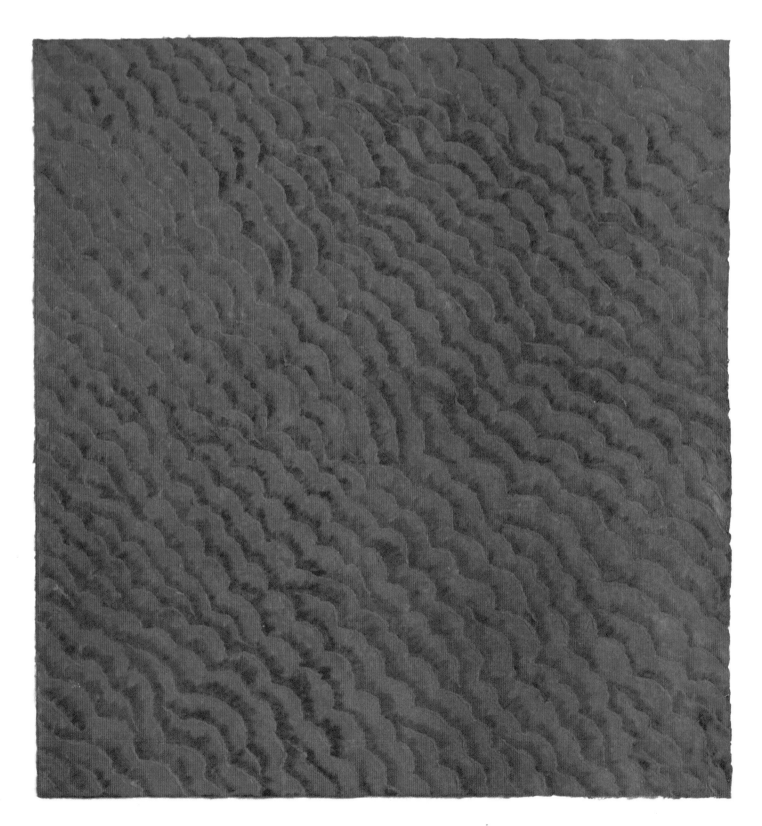

Currents Red
2000
handmade paper, pigments,
mixed technique
90 x 85cm

Born	1944, Sunndal, Norway
Atelier	Bergen, Norway
	www.bgnett.no/~ijb

Education and Awards

1964-68	National College of Art and Design, Oslo
1970-71	College of Art and Design, Bergen, Norway
1987-88	West Norway Academy of Fine Art, Bergen, Norway
1993	Annual grants from the Norwegian Government

Exhibitions

2004	Gallery Brevik (solo), Tromso, Norway
2003	National Museum of Fine Art (solo), Kaunas, Lithuania
2002	Gallery s e (solo), Bergen, Norway
	The 4th International Women's Art Festival, Le Pont Gallery, Aleppo, Syria
2000-2001	'Norrut': ASI Art Museum, Reykjavik, Iceland
	Bryggens Museum, Bergen, Norway
	Museum of Art and Design, Helsinki, Finland
	The Nordic Embassies, Berlin, Germany
	The National Gallery of Fine Art, Kaunas, Lithuania
2000	Museum of Santa Maria della Scala, Siena, Italy
1998	Holland Paper Biennial, Rijswijk, The Netherlands
1995	'Encounters', Jordan National Gallery of Fine Art, Amman, Jordan
1994	'Golden Autumn', Russian Museum of Decorative Art and Folk Art, Moscow
1992	The IVth International Biennial of Paper Art, Leopold-Hoesch Museum, Düren, Germany

Commissions

Tredal School, Sunndalsora, Norway
Sunndal Town Hall, Sunndalsora, Norway
Stavanger University College, Stavanger, Norway

Collections

Norwegian Arts Council
The National Gallery of Fine Art, Kaunas, Lithuania
Royal Palace, Amman, Jordan
Russian Museum of Decorative Art and Folk Art, Moscow

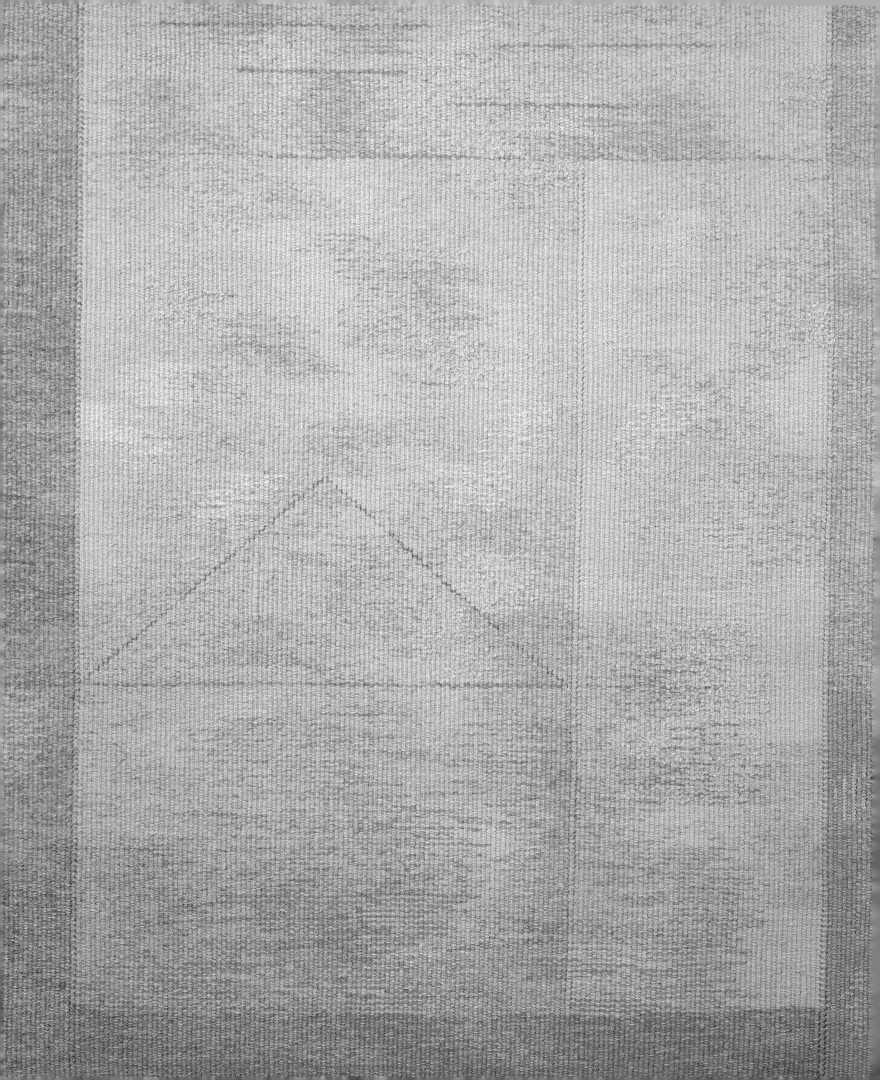

Marianne Mannsaaker

The play between colour, surface and line, the texture of the threads, different brilliance and mattness is the result of the basic intention to paint with thread.

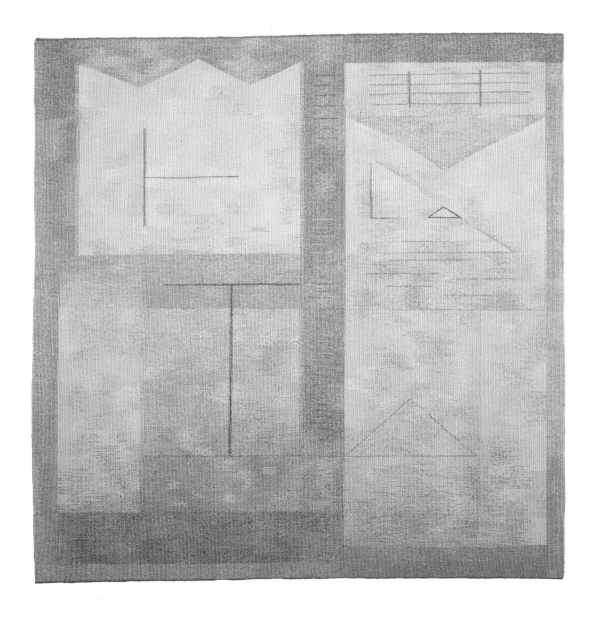

Rime Frost
1997
tapestry
wool, linen, silk
200 x 200cm

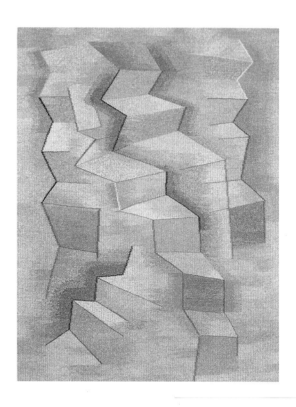

Steps
1991
tapestry
wool, linen, silk
200 x 150cm

The choice of tapestry as the principal medium of my art is not solely a material one; weaving has as much to do with a certain choice of time. The slowness of weaving corresponds to the rather long drawn out creative process, at a spiritual level, of most of the pictures that I make. The image is built up laboriously through several phases, resembling an inverted archaeological process. The medium conquers time, so to speak, it allows extra strata of meanings and nuances, and charges it with an underlying pulse.

I challenge an ancient tradition with the use of contemporary imagery. My images appear abstract but generally refer to something concrete – architecture, music, text or other pieces of art. My recent images are increasingly associated with imaginary maps, secret letters or music scores. The references to art history as well as to contemporary art are more like shifting dialogues with friends than the pursuit of ideals. These dialogues inspire, correct and challenge me.

Often, early in the development of an idea into an image, whilst merely a fumbled fragment of words, or a crude sketch in a drawing book, the creation has a name. This name gives the idea a body, and the name is rarely changed during the process. The picture, however, virtually always undergoes continual changes, a metamorphosis, until its final stage is reached. The picture's title guides the work like a compass reading to which I must deem loyalty.

My warp is always of linen. This choice of material as a foundation for my images is as obvious for me as it is for most painters. The weft is principally of wool. One particular Norwegian sheep race wanders the hills all year and has, therefore, especially long-fibered and glossy cover-hair. This is spun into thread. This wool absorbs and maintains colour very well. I dye all my yarn myself, that's part of the skill magic. My dye cauldrons and balls of yarn are my palette.

As an artist, my encounter with Berber culture was a turning point, moving the focus from painted to woven pictures. Among the Berbers, the art of weaving has a central position and their language is a manifestation of this. Several Berber words have double meanings, describing both important areas of life as well as phenomena related to weaving. The word for the bottom bar of the loom can also mean 'of earth'. The word for the upper bar means 'of heaven'. Thus the tapestry can be said to connect earth and heaven. 'Erruh' is the crucial point where warp and weft meet, but it also means 'the soul'. The title of my work *Thanes Lith* [see p 32] means to cut down the finished tapestry from the loom and also to give birth.

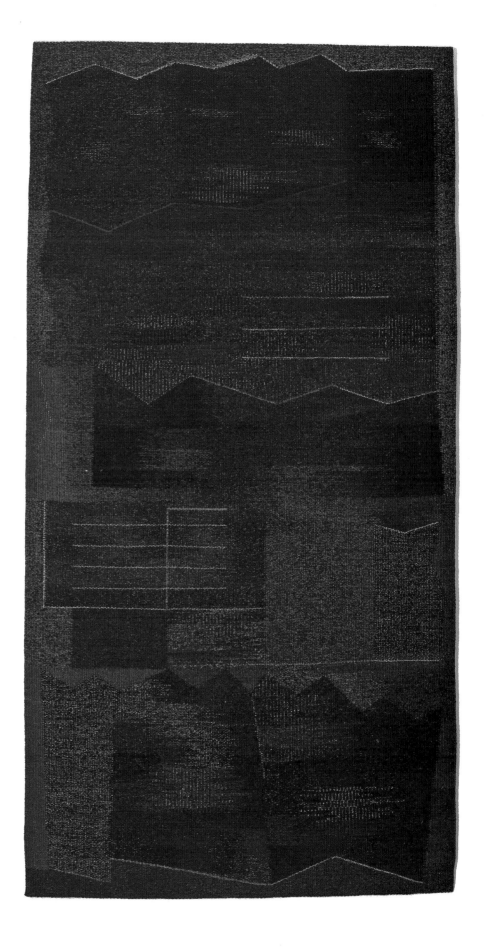

Hiding Places
1993
tapestry
wool, linen, silk
200 x 100cm

My images appear abstract but generally refer to something concrete – architecture, music, text or other pieces of art. My recent images are increasingly associated with imaginary maps, secret letters or music scores.

left:
Thanes Lith
1988
tapestry
wool, linen, silk
200 x 135cm

above:
Zuina
2001
tapestry
wool, linen, silk
150 x 200cm

My art is positioned across the categories of drawing, painting, tapestry and photography, and includes them all as they cross-fertilise each other. But my starting point is painting and from this point there are two routes: one where the paintings are sketches for tapestries, another that is paintings and drawings which are complete works in themselves. This 'other' dimension of work runs parallel with my better known and more recognised tapestries. However, my most important images are woven.

In my house I have a violin, and an old dream that I could play it. The strings are my instruments above others. When I am selecting solo music, it is invariably for a stringed instrument. In weaving, my dream is fulfilled. The loom with its tense warp is my harp, my cello. The weft threads that build the image are the bow.

Afterimages no. 22
2004
drawing
charcoal on canvas
100 x 75cm

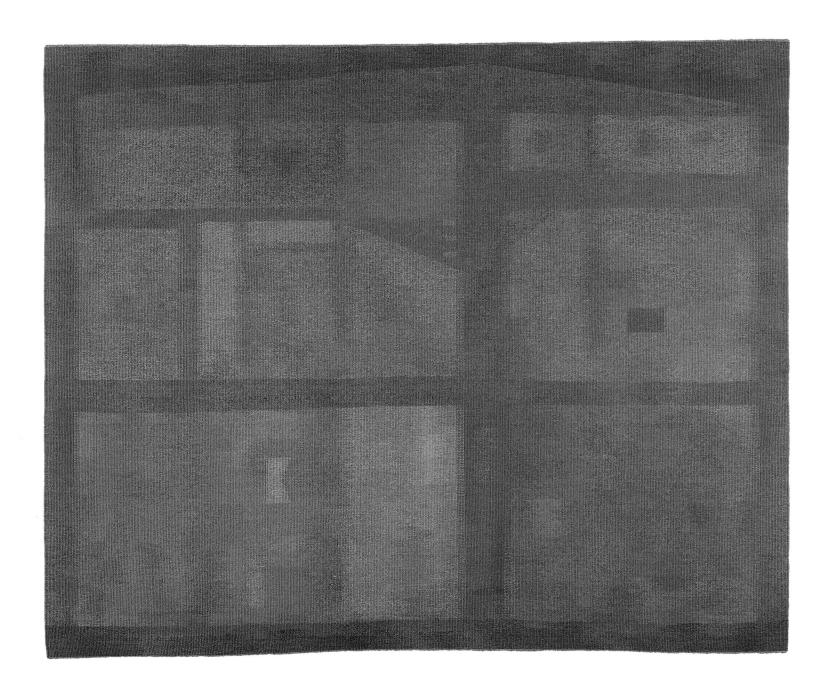

Topology of an Imagined City
2003
tapestry
wool, linen, silk
200 x 250cm

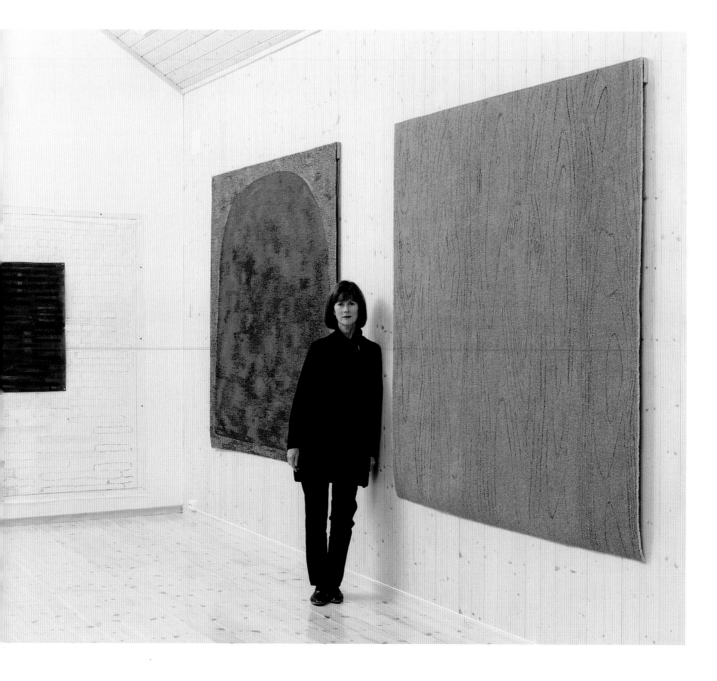

My loom is an old vertical model with iron weights. Looms like this have been in use since the Stone Age, and I like to consider myself part of a long chain of weavers through history.

behind the artist:
Irr
1997
wool, linen, silk
200 x 200cm

in front of the artist:
By the River
1998
wool, linen, silk
200 x 200cm

Afterimages no. 24
2004
drawing
charcoal on canvas
100 x 75cm

| **Born** | 1951, Oslo, Norway |
| **Atelier** | Galterud, Norway |

Education and Grants
1972-76	National High School of Arts and Crafts, Oslo
1981-83	Academy of Fine Arts, Cracow, Poland
1988-90	Government 3-year artist grant
1992, 94, 95, 97, 98	Vederlagsfondets grant
1999	Government guaranteed annual grant

Exhibitions
1999	Modern Norwegian Tapestry Art, National Gallery, Bucharest
1998	Christiansand Art Hall (solo)
	Bergen Art Hall (solo)
1997	International Textile Triennale, Tournai, Belgium
1996	Norwegian Art in Slovakia
	Kunstnerforbundet (solo), Oslo
1992	New Norwegian Tapestry, Trondheim
	Museum of Contemporary Art, Oslo
1991, 94	Norwegian Pictures, Gallery Brandstrup, Oslo
1989	Group X3M, Norway and Finland
	Norwegian Textile Art, Moscow
1984	Gallery Tanum (solo), Oslo
1982-93	Nordic 3, 4 and 6. Textile Triennale
1981-92	National Annual Art Exhibition, Oslo

Commissions
2001	Lillehammer Town Hall
1989	Norwegian Science Council, Oslo
1985	State Hospital, Oslo

Collections
1991 and 1996	Norwegian Art Council
1989 and 1991	Museum of Contemporary Art, Oslo
1988	Oslo Art Collection

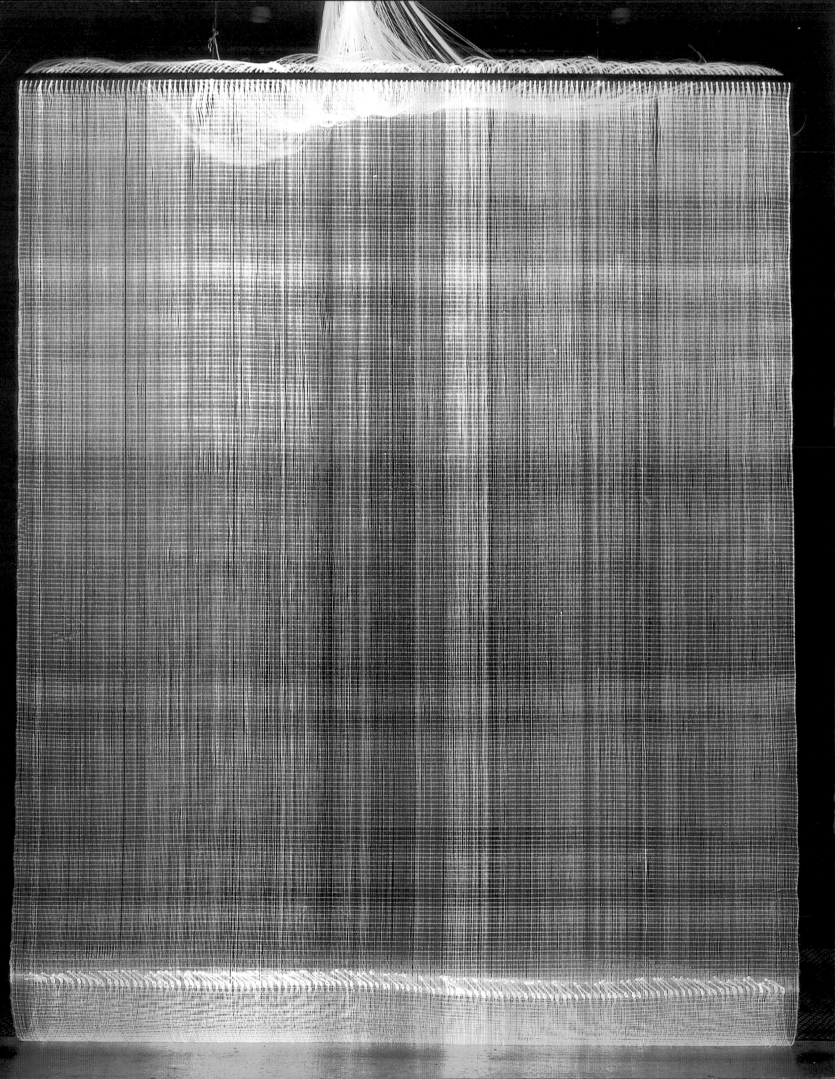

Astrid Krogh

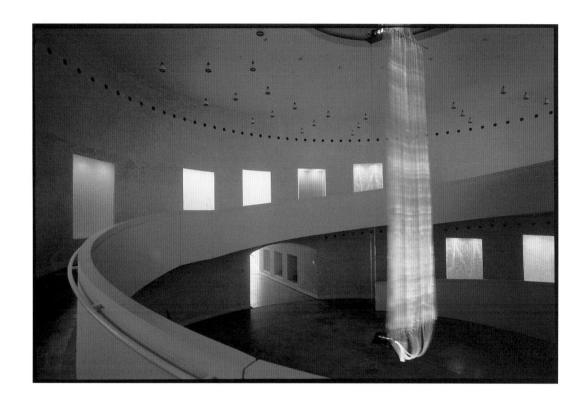

As a textile designer, I have always been interested in textiles and how the light is transmitted through them, how structure in the textile can create the most beautiful shadows.

left:
Blue
2002
woven optical fibres
300 x 250cm

above:
Lightmail
2000
woven optical fibres
150 x 800cm

For my first solo exhibition, I worked with curtains in a variety of materials from plastic to fibreglass. My focus was how the daylight was transmitted and changed through the textiles. I was researching all kinds of new materials when I discovered optical fibre.

It was a revelation to discover a material where I was able to weave with the light itself! I was able to control the light, in distinct contrast to daylight – a fact that makes the daylight fascinating too.

I started to work with artificial light and found that living in a big city was a great advantage because of the variety of kinds of light. Light is almost the pulse of a city.

Light also brings surprises and challenges perception. I am interested in the space between the neon tubes. When two different coloured neon tubes are placed at the right distance from each other, a third colour is achieved. Because light is immaterial 'there is still no beginning and no end'. The light runs along its own ray, like a drop flowing down the river, disappearing, changing character and reappearing.

Another of my interests is pattern. When is a pattern a pattern? Is it when we have exact repetition or can the repeat vary slightly? From water, I find inspiration again and again. It has this 'pattern-rhythm' which I like very much. The 'structure' on the surface forms a water pattern, but a constantly changing pattern. What fascinates me is that no moment is the same and so, for me, it is a proof of life, a growing life. Ice crystals do the same, they grow, always in a slightly different formation but with the same 'ground element'.

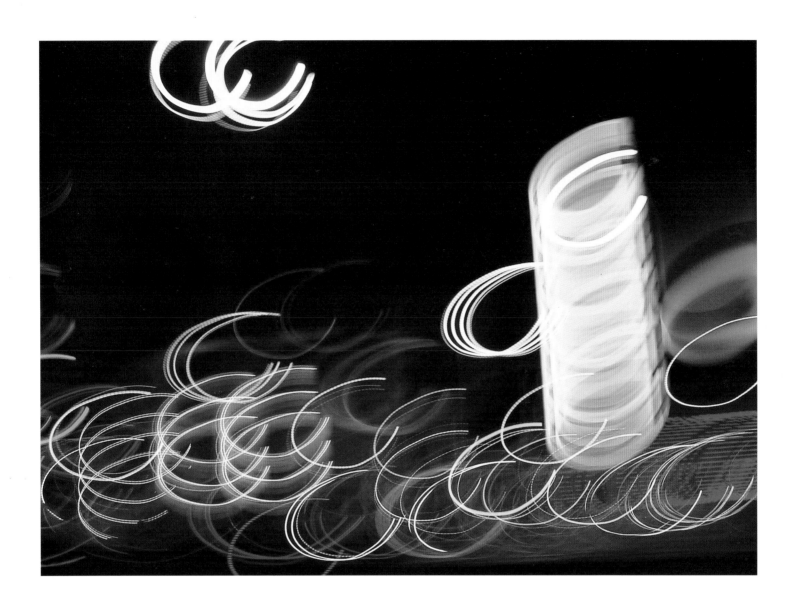

Citylight
2001
photography

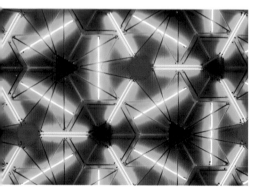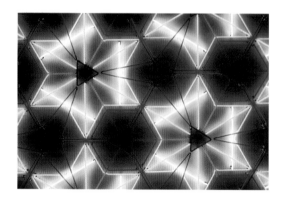

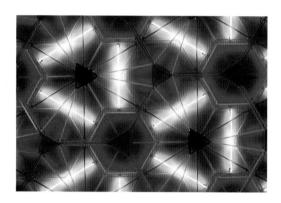

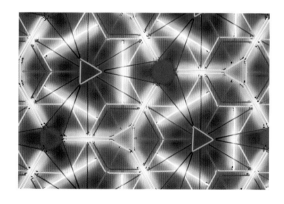

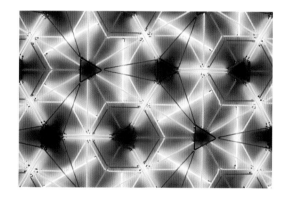

Ornament
2003
neon tapestry
260 x 360cm

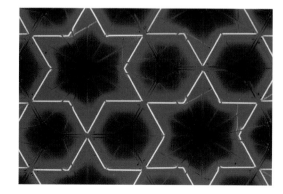

I was commissioned by Mærsk Data to do something for their building [right]. On the top of the building there was already a neon advertisement for chocolate. It is very old and well known all over Copenhagen; a sweet and funny frog jumping around. I wanted to do a decoration that would, in a sense, communicate with the frogs and would change over time. That is why I chose neon.

I made a play of daylight and neon interfering with stainless steel mesh. I wanted it to be a living, constantly moving surface; changing with the season, the weather, the time and even with the movement of a head, as though it were grey steel moiré. Towards evening the colour from the neon tubes appears more vividly, and at night the decoration stands as a shining wall, seen clearly from outside, the neon itself changing every 15 minutes.

DSB, the Danish state railway, commissioned a piece for the historic meeting room of its 18th century headquarters. The room already had some very heavy furniture, poor lighting and a 1940s painted ceiling.

We (myself and Puk Lippmann) made tapestries of woven steel filters, which produce interference patterns both in daylight and when the light behind them is on. The result is a space that is constantly transformed by changing light – echoing the rhythms of the days and the seasons, or by adjusting the setting of the electric light.

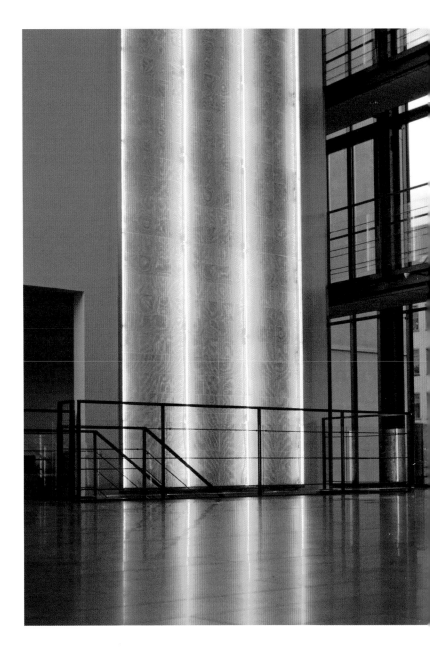

Wall decoration
Mærsk Data, Copenhagen
2001
woven stainless steel
4 x 14m

In the Danish Parliament I was commissioned to produce a decoration that gave light and colour to one of the long, very dark corridors previously hung with heavy gold framed pictures. The idea was to create a 'light room' where you would have a very physical 'light experience'.

Polytics consists of neon tubes in combinations of circles, floral patterns and lines - a paraphrase of a repeating pattern in the central hall of the parliament that constantly if imperceptibly varies. In reference to this, I wanted to make a piece that changed slightly all the time but kept the same motif. The work is set in a niche and is only experienced in its entirety from close by. From further along the passage, it is the lit space around the work that is visible. Every 45 seconds the neon tubes change in almost infinite combinations of light and colour.

I still have several ambitions to fulfil; I would very much like to work with new light technologies, like LED for example. On the other hand, I would very much like to make a marble floor with a 21st century pattern to last 1,000 years like those fantastic floors in Rome. In addition, I will also continue with exploring new limits or new expressions in textiles.

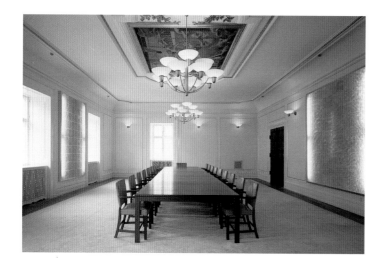
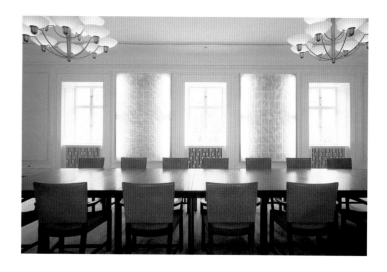

Wall decoration
DSB, Solvgade, Copenhagen
2002
woven stainless steel
250 x 250cm

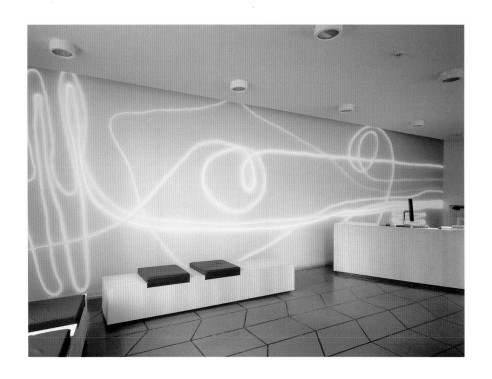

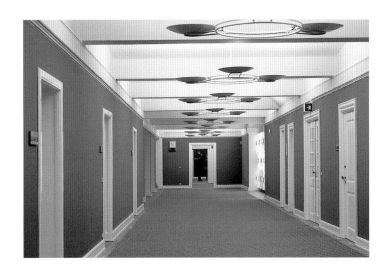

I would very much like to work with new light technologies, like LED for example, but I will also continue with exploring new limits or new expressions in textiles.

above:
Polytics
Wall decoration
Folketinget, The Danish Parliament
2003
neon tapestry
240 x 720cm

top:
Wall decoration
Reception DSB, Solvgade,
Copenhagen
2001
glass, optical fibre
2.5 x 10m

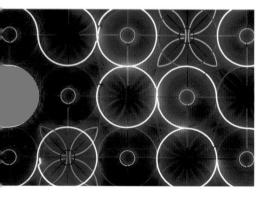 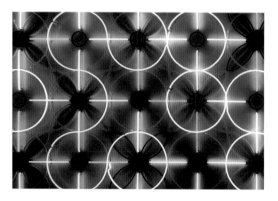 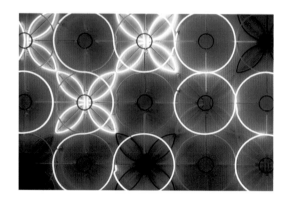

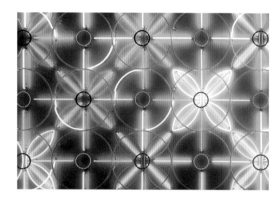

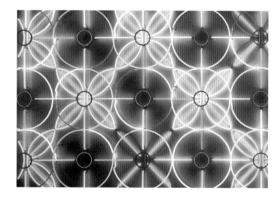

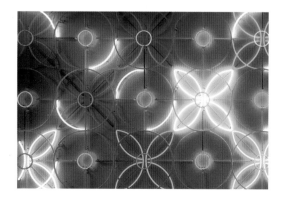

Polytics (detail)
Wall decoration
Folketinget, The Danish Parliament
2003
neon tapestry
240 x 720cm

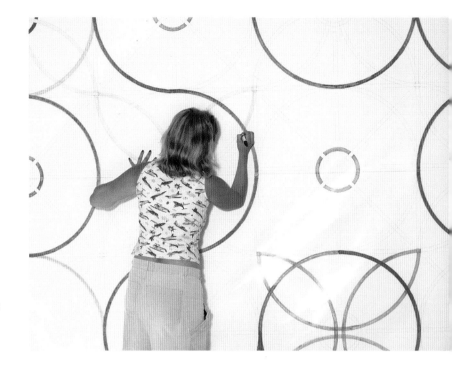

Born	1968, Strellev, Denmark
Atelier	Copenhagen, Denmark
	www.astridkrogh.com

Education and Awards

1992-97	The Danish Design School, Copenhagen
2002-06	Grant, The Danish Arts Foundation
1999, 2000, 2001	Grant, studio, Danish Art and Crafts Centre, Copenhagen

Exhibitions

2004	'Stuff', Danish Cafts, Toronto
	11th International Triennial of Tapestry, Lodz, Poland
2003	'Scandinavian Design', Kunstgewerbemuseum, Berlin
	'Derfor', Danish Craft at Paustian, Copenhagen
2002	'Tapestry' (solo), Danish Museum of Decorative Art, Copenhagen
	'La tradition de demain', Maison du Danemark, Paris
2000	'Light Mail' (solo), Trapholt Art and Design Museum, Denmark
	'Young Nordic Design', Scandinavia House, New York
	'Danish Wave', Peking, China
	'Danish design and architecture' (tour)

Commissions

2004	Circus Museum, Copenhagen
	Grønnegades Cultural Centre, Næstved
2003	Folketinget - The Danish Parliament
2002	DSB (Danish State Railways)
2001	Coloplast A/S, Velux A/S
	DSB (Danish State Railways)
	Mærsk Data A/S, Copenhagen
1999	Lightscreening, Royal Library, Copenhagen

Collections

The Danish Arts Foundation

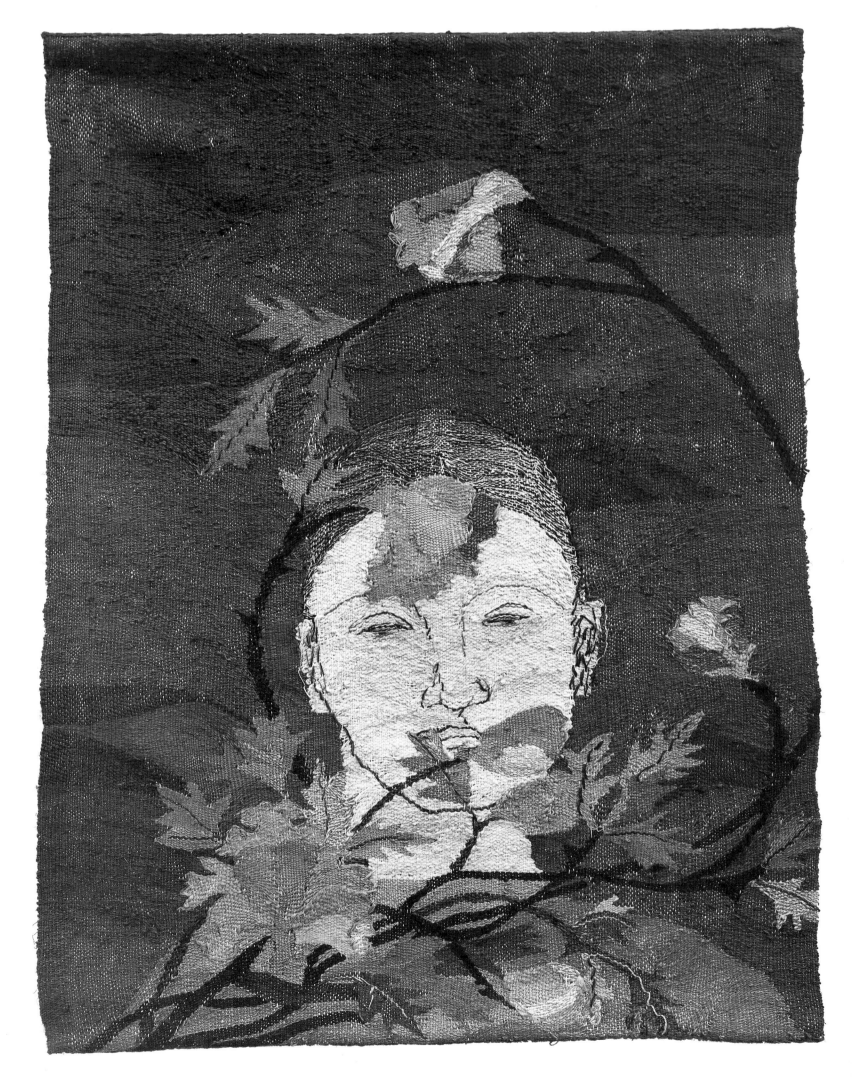

Aino Kajaniemi

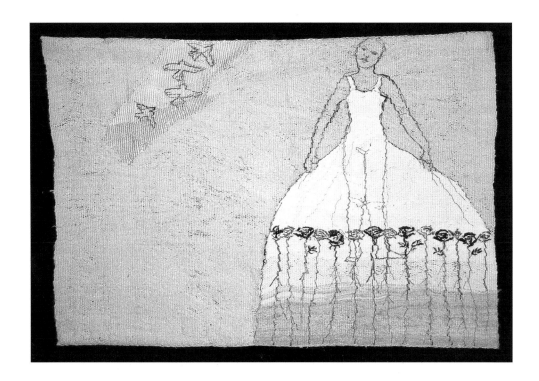

Lonely working and the possibility of meeting somebody through my works. The discipline of technique and the unlimited creation. Hidden beneath simple forms and sketch-like outcomes, I use old and difficult techniques. In a way it resembles ballet, where the dance seems easy and light as a feather, but in reality the training and sheer effort is as heavy as lead.

left:
Enchantment
2002
linen, cotton, wool,
hemp, viscose, tapestry
58 x 43cm

above:
A While 2
2002
linen, cotton, viscose,
tapestry
30 x 40cm

I had a very traditional upbringing and in my childhood home we appreciated the skill of handicraft, though the appreciation was theoretical because the traditions had been abandoned as people moved to the city. As a child I accepted the role of girls needing to know needlework, but later, on I added my rebellion to this skill and started to make pictures from thread.

15 years ago I moved back into my childhood home to take care of my parents. They died the following year. The same year I had my second child . From these extreme experiences of life and death, my career as an artist began. I still live in my childhood home with my husband, 18-year old daughter and 14-year old son. Here, the eras collide - my memories and the present. Fortunately, everyday life is the more powerful influence; I don't live in the past, or in the future. Every morning, I go to the cellar to weave, and I work until evening.

When I work for exhibitions, I can be selfish and concentrate only on my own thoughts, on what I think is important in life. My textiles are my way of thinking. I want to present the subjects of my wondering in concrete form, to help me understand them.

I have also had the pleasure of making public commissions for several government, community and company spaces, and of planning and making religious textiles for five churches. Commissions give my work a totally different focus. I have to think about the architecture and the people that are to work around my textiles.

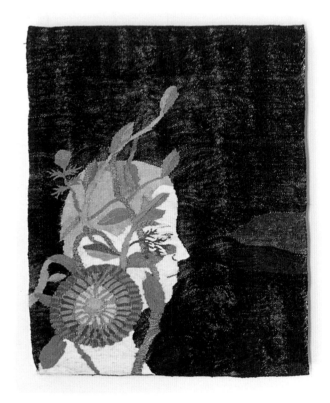

Enchantment (part of series)
2002
linen, cotton, wool, hemp,
viscose, tapestry
each 58 x 43cm

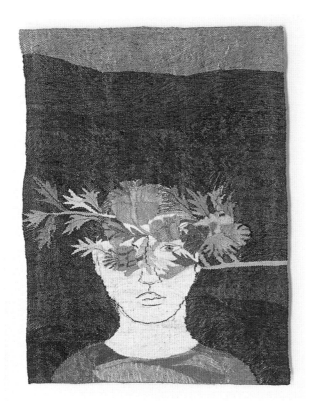 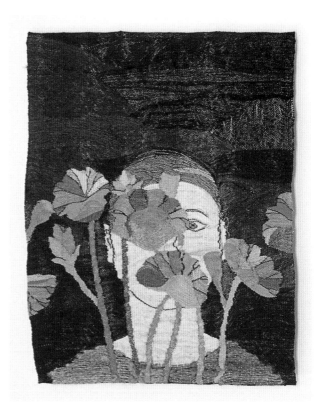

The subjects of my work usually originate from the innermost heart of a human being; sorrow, joy, uncertainty, guilt, tenderness, memories, and so forth. I am interested in the symbolism of pictures, in ancient messages hidden in pictures.

My tapestries are small, graphic line-drawings. I like to draw, black lines on white, white lines on black, and the tones between them. I use more shades than colours. But five years ago, I travelled to Mexico to study colours. I had noticed that colours give a lot of joy and energy and I wanted to use them. But you can't force it, all progress comes with time. I make many different kinds of textiles; but I find that most things can be expressed in a minimal way. It's easier for me to describe sorrow than happiness.

I like rough and smooth materials, disagreement and discussion between them. Clumsiness and sensitivity. I build a balance of contrasts: a moment frozen in time and the patient time-consuming effort. A spirit of the contents and the present sense of touch. Lonely working and the possibility of meeting somebody through my works. The discipline of technique and the unlimited creation.

I appreciate simplicity, but tend to work things out in a complicated way because clarity doesn't seem to be part of my working-day. I think of everyday problems, and then visualise them indirectly. Motifs that I like to use to depict womanhood have been roses and lace. Both have complex messages, beauty and thorns, hiding and revealing, sin and forgiveness.

I discovered lace when I was in Kalmar in Sweden, for a Nordic textile event that was organised to celebrate the 600th birthday of Queen Margareta and the Union of Kalmar. I thought about the image of a queen wearing lace and made 8 see-through lace tables out by the sea. Afterwards I discovered that in the 14th century they didn't wear lace! It troubled me so much that I had to weave a piece about a Queen with a large lace collar. I named the piece *Burden* [right].

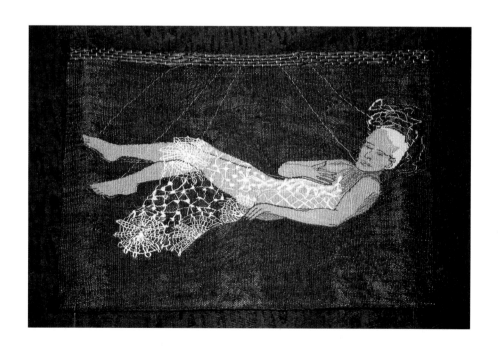

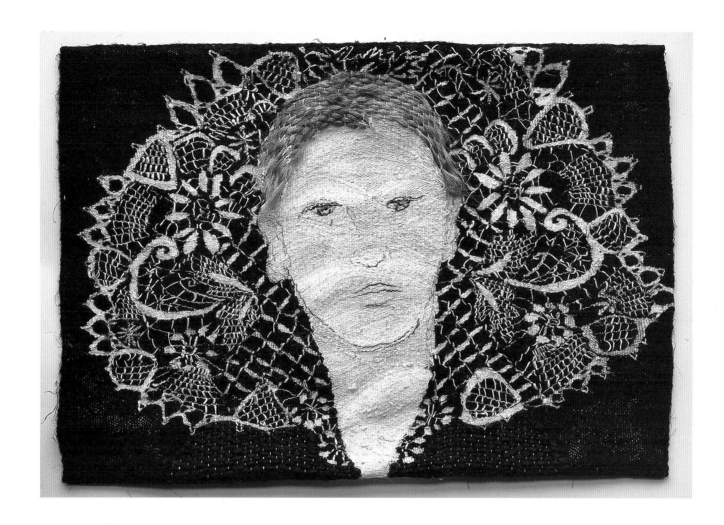

left:
Love
2001
linen, cotton, viscose,
tapestry
30 x 40cm

above:
Burden
1997
linen, cotton, viscose,
silk, hair, tapestry
30 x 40cm

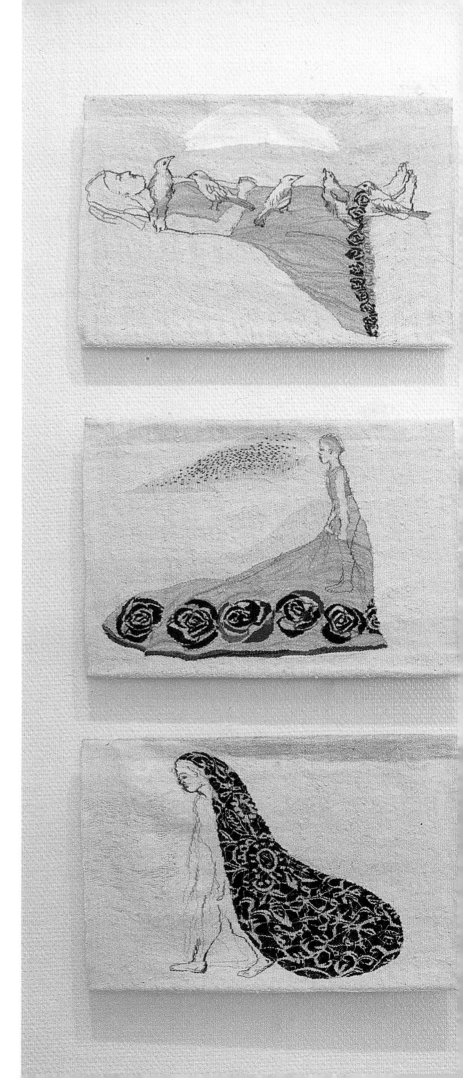

A While

2002

linen, cotton, viscose, gold,
wool, hemp, tapestry

nine pieces, each 30 x 40cm

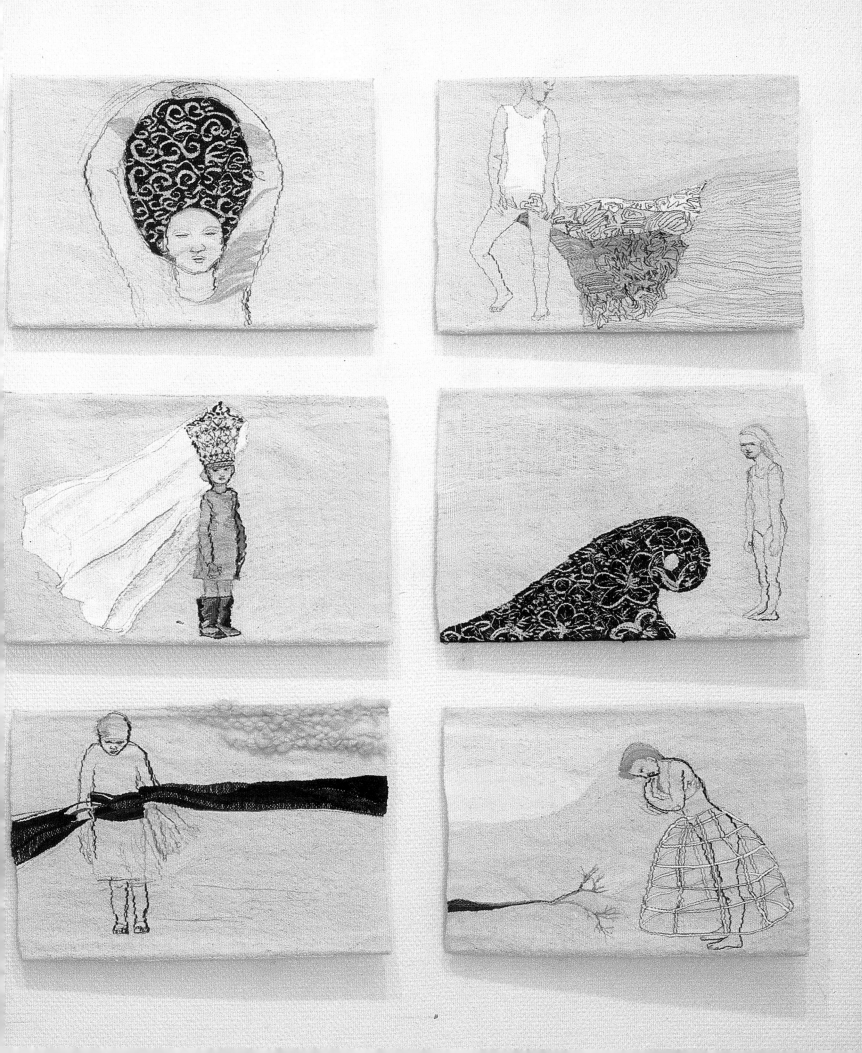

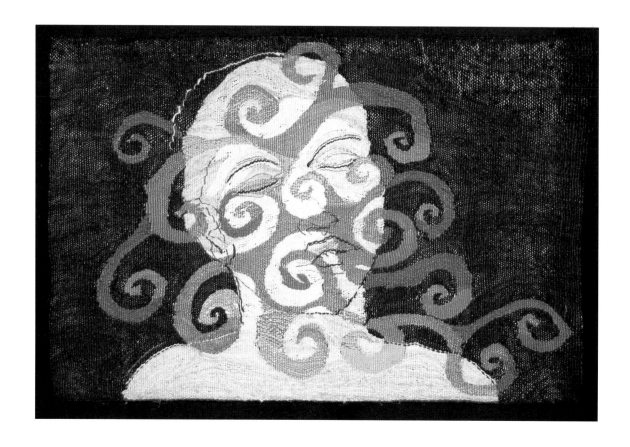

Textiles bring us memories through skin; they can bring happiness, by touching materials one can live the past into reality. In this way my textiles become intimate. I haven't yet found my limit, there is still something to search for and find. In this way I want to weave my works out into the world.

A Party
2001
linen, cotton, wool,
silk, tapestry
30 x 40cm

Born 1955, Jyväskylä, Finland
Atelier Jyväskylä, Finland
 http://personal.inet.fi/taide/aino.kajaniemi

Education
1983 University of Art and Design, Helsinki

Exhibitions
2003 'Textilia' (solo), Gothenburg, Sweden
2002-3 6th Finnish Textile Triennial, touring exhibition
 10th International Lace Biennial, Belgium and Germany
2002, 1996 Festival International de la Tapisserie, Beauvais, France
2002 Miniart textiles, Galerie u Prstenu, Prague
2001-2 'Tondo Finlandaise', La Spezia, Pisa, Bari, Genova, Italy
2001 'Tradition & Innovation', The State Art Museum, Riga, Latvia
 Total Museum of Contemporary Art, Seoul
 Applied Art Museum, Belgrade, Yugoslavia
2000 Gallery X, 3+3, Bratislava, Slovakia
1998 Gallery for Applied Art (solo), Bau, Helsinki
 TEXO exhibition, Escuela de Arte "La Palma", Madrid
1997 'Useless Things', Applied Art Museum, Tallinn, Estonia
 Musée de la Tapisserie, Tournai, Belgium
 'Ögonblick Norden', The Theatre Gallery, Kalmar, Sweden
 Three textile artists, Academia Gallery, Vilnius, Lithuania
1996-97 40th Jubilee exhibition of TEXO, Helsinki
1995 Museum of Central Finland (solo), Jyväskylä
1994 Miniartextil, Villa Olmo, Como, Italy
 Gallery Hagelstam (solo), Helsinki

Collections
 State of Finland
 Cities of Helsinki, Jyväskylä, Kemi, Kotka and Vaasa

Commissions
1985-2004 for Helsinki, Jyväskylä, Kemi, Oulunsalo, Lisalmi
1986-2004 Churches: Helsinki, Jyväskylä, Kemi, Veitsiluoto, Palokka

Ane Henriksen

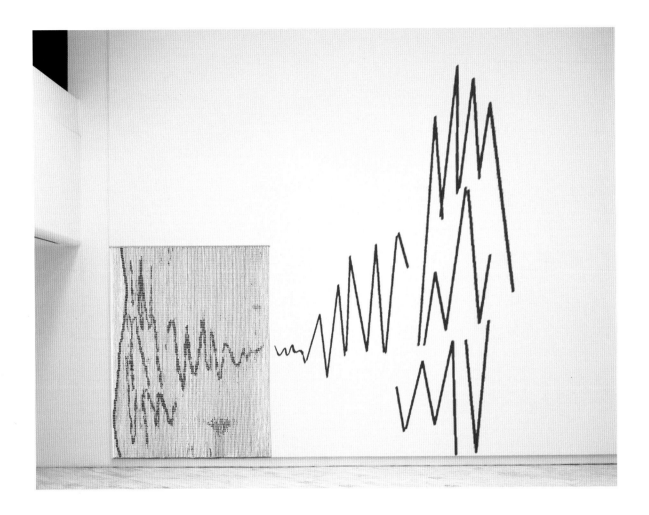

A tie, a deep human intimacy, smashed to pieces. My aching, broken heart and body, drawn with a desperate line, like a bad-tempered umbilical cord. Or alternatively an expression of hope, the fluttering of a butterfly, out into the intangible new space. Will you, will you, will you, will...

Black & Blue
2003
silk and cotton,
free cotton drawing
245 x 186cm

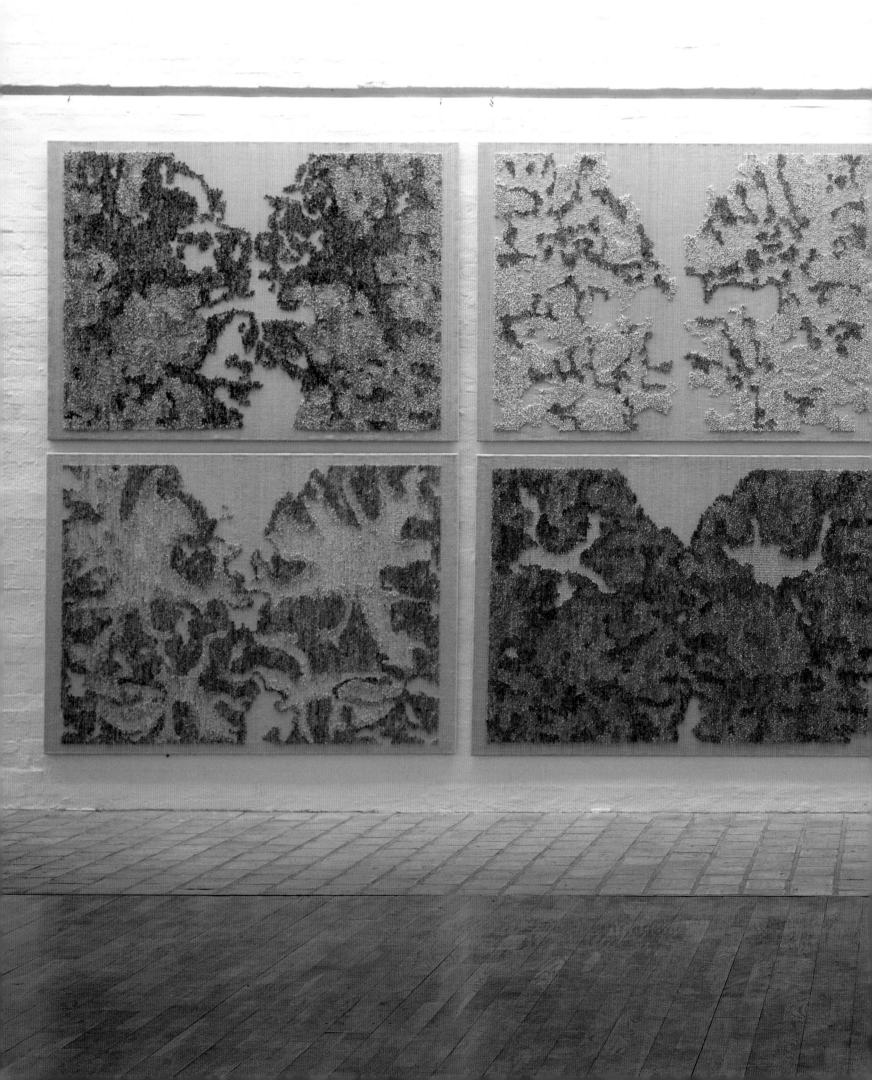

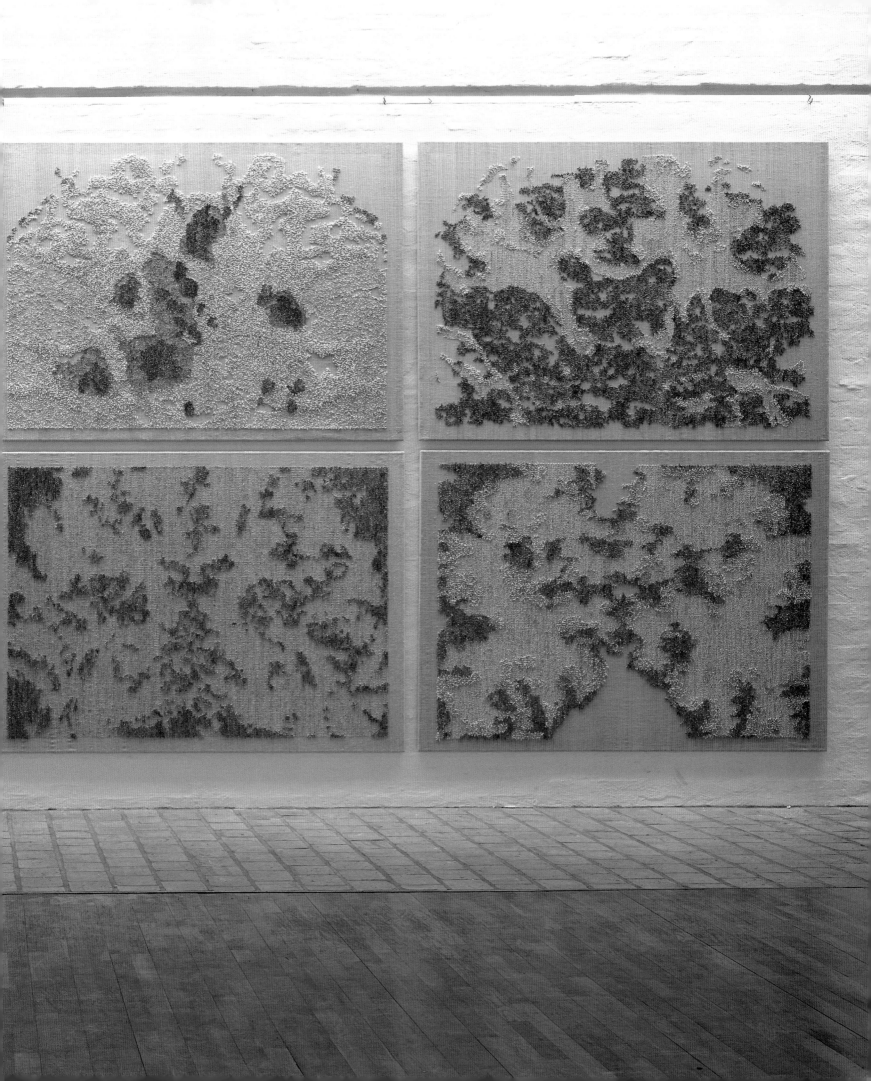

My pictures are, in a sense, like my skin – an expression of something vulnerable. I try to contain the world around me and transform it to fit my reality – to a new kind of internal logic, a stillness. Repulsive yet appealing – aesthetics on the threshold of pain – searching, with a mixture of doubt and conviction?

My humour fills so much, thoughts interrupt my concentration, I am confused and contradictory, which is perhaps why I need to try to create silence. I spin around and around myself for ages before reaching the essence – or else I stand motionless like an animal on the scent, while countless nuances of sensitivity are filtered. How can I put wings to pain?

With emotion-bearing threads, I want to form a space, and the possibility of escape. I do not try to distract the viewer's attention, but to call them to attention – and perhaps awaken them to wonder. I would like to sound quiet tones, whilst seeking to understand my world. I dream of embracing the world – not of convincing it. I shout quietly.

I relinquish my dispersed knowledge, and find my concentration at the loom. Sometimes I find source materials among the flotsam and jetsam of the beach. My colour palette is a narrow one, as if restricted by oil spills on the sea. I work from a theme, or in a series – where one piece works with its neighbouring piece – in a quest for balance. The structure stands open, and there, where lines and processes distract, thought connects.

My life is

Filled with

Invisible threads

That bind

Me

page 4-5
Nature un Nature
1995-96
flax, silk, acrylic painted
underlay, synthetic rubber
282 x 790cm

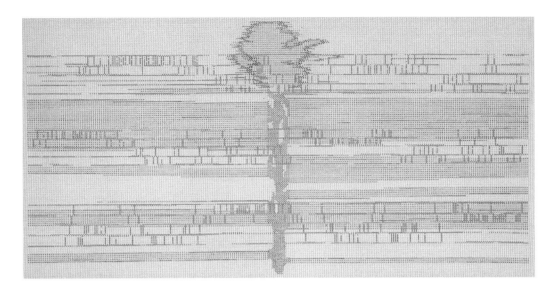

Strike A Note
2000
flax, cotton, acrylic painted
underlay, synthetic rubber
140 x 280cm

Genetic Green
1999
flax, cotton, acrylic painted
underlay, synthetic rubber
140 x 280cm

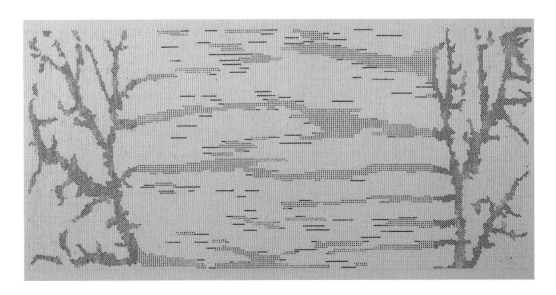

Cut off the Branch...
1997
flax, silk, acrylic painted
underlay, synthetic rubber
140 x 290cm

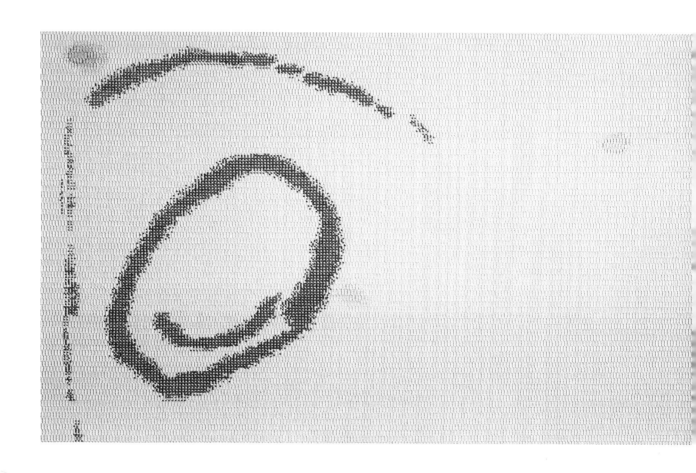

Contour to Reconstruction
2003-04
flax, cotton, acrylic painted
underlay, synthetic rubber
142 x 470cm

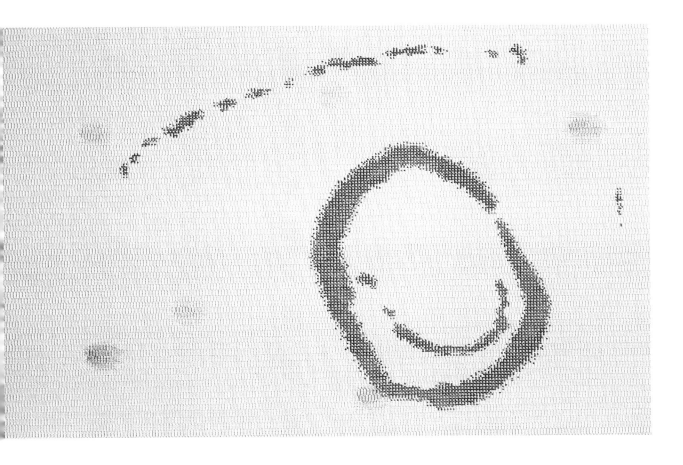

Like an illustration for pulp literature? In an attempt to show the enormous fragility of the beginnings of a new life after divorce, I keep the picture as a sketch, as an expression of something searching. Is the world waiting? The technique – a kind of woven cross-stitch embroidery – lends a feminine association to the motif, with a galaxy of imperfections.

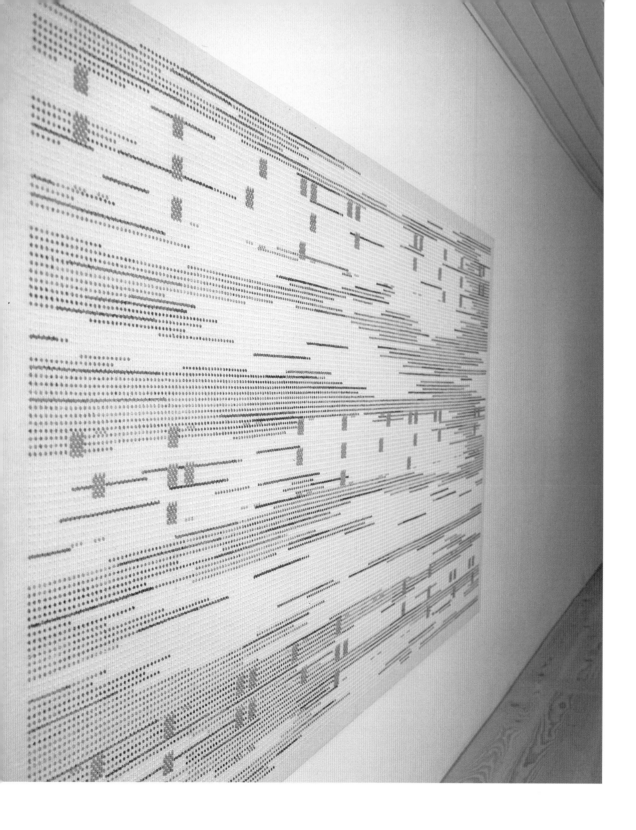

The Blind Leading the Blind
2000
flax, cotton, acrylic painted
underlay, synthetic rubber
140 x 280cm

My story begins, innocently playing on my computer, as I stretch nature. I am reminded of the deadly seriousness of scientists at play, as they experiment with the very make-up of our food, which they alter and manipulate. I comment upon my fear of genetic modification by adding Braille (formed by orange rubber protruding through the woven surface) together with the title, a reference to Pieter Brueghel's painting of the same name.

Born	1951, Randers, Denmark
Atelier	Copenhagen, Denmark

Education and Awards

1970-74	School of Arts and Design, Kolding, Denmark
1992	Outstanding Award, International Textile Fair, Kyoto, Japan
1993	Award, the Danish Academy Council
1991	In our Hands 1, Nagoya, Japan

Exhibitions

2004, 02, 01	SOFA, Browngrotta Arts Gallery, New York, Chicago, USA
2004, 99, 97, 95	Biennale of Arts & Design, Museum of Decorative Arts
	Trapholt Kunstmuseum, Kolding
	Nordyllands Kunstmuseum, Aalborg
2003	'The Common Thread', Westport Arts Center, USA
2001	'Natur Lighed' (solo), Holstebro Kunstmuseum, Denmark
	Karpit, Museum of Fine Arts, Budapest
2000	'A Scandinavian Sensibility', Browngrotta Arts, Connecticut; North Dakota Museum of Art, USA
	'Trame d'Autore', 2nd Fiber Art Biennale, Chieri, Italy
1999	'Danish Tapestry', National Museum of Scotland, Edinburgh
	Galleri MXespai (solo), Barcelona, Spain
1998	'Natur u Natur' (solo), Skive Kunstmuseum, Denmark
1997	'Tracing Purpose', Leedy Voulkos Art Center, Kansas, USA
	'Fio 2 Brazil', Rundetaarn, Copenhagen, Denmark & MASP, Sao Paulo, Brazil
	3rd Internationale Textile Triennale, Tournai, Belgium
1996	'Tendenser', Galleri F15, Moss, Norway
1995	8th International Triennial of Tapestry, Lodz, Poland
1993	'Flexible 1' – Pan-European Art, Germany, Holland, Poland
	13th Fiberart International, Pittsburg Center for the Arts, USA
1992	3rd International Textile Competition, Museum of Kyoto, Japan

Publications

1998	Ane Henriksen, Rhodos - Fine Art Productions 1998 [ISBN 87 7245 747 3]

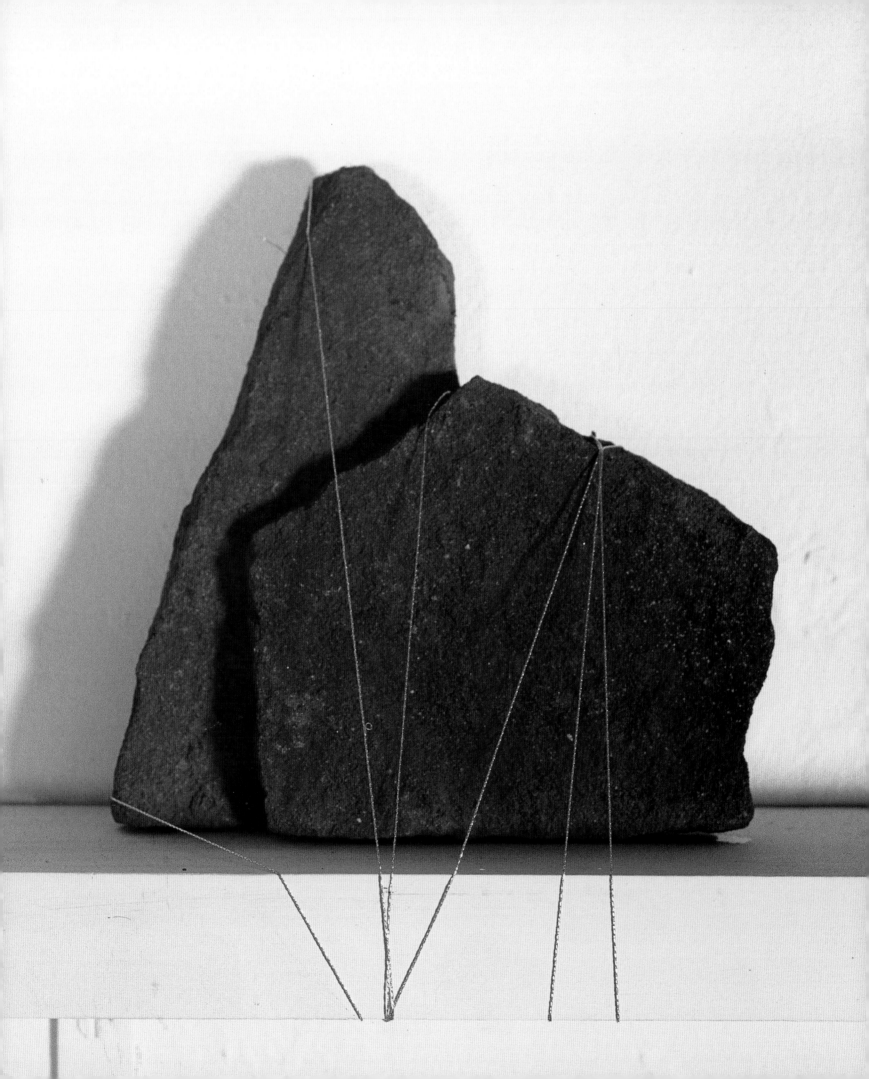

Anna Lindal

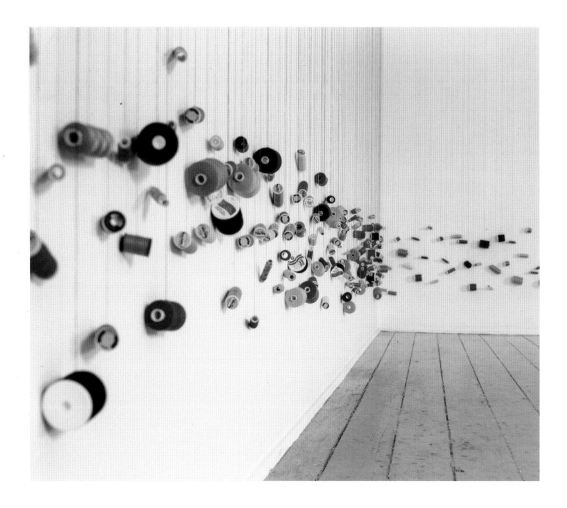

The accumulation of over 1,000 spools, each thread hanging by a single needle in its own hole, gained a certain majesty... How quietly women have gone about their business, attending to and mending material, emotional and spiritual 'holes'.

left:
Untitled
1990
stone, thread
20 x 42 x 8cm

The Mender (detail)
1994
installation
1138 cotton reels
and needles
variable dimensions

My artistic practice is directly related to my everyday engagement with the world. The work is preoccupied with issues of routine, labour, everyday gestures. Installations use 'invisible' everyday objects, invisible in the sense that they are things we do not normally pay much attention to – coffee cups, bobbins, a shovel, a bucket, spoons and forks and sugar cubes. The works use material from my surroundings, materials that belong to my normal life. These are materials that, on the one hand, might be considered oppressive, but they are used so obsessively that they are pushed to the limit and become, at times, playful and theatrical. My use of everyday materials and traditional skills can be seen as both celebratory and critical of historical and cultural practices. I also makes reference to ways in which the mundane in life can be double edged, both amusing and deadly serious.

Many of my works have the character of diary entries; they are stimulated by a perception of events that needs further examination. For example, the conceptual framework of *The Mender* (1994) developed during what was an introspective period for me, following the birth of my second child. I was preoccupied by thoughts about what makes life into life. For this installation, the gallery's walls were covered with threads of over 1,000 spools, each thread hanging by a single needle in its own hole. All the details – needles, threads and spools – together build a majestic whole, greater than the sum of its parts. This was a kind of conclusion after looking at how quietly women have gone about their business, women who are constantly mending both material and spiritual 'holes', tending to the basic factors of human existence and survival. The desire was to move the works through the intimacies and minutiae of personal life into a broader, public sphere.

Recent works combine needlework and video to make sculptural installations. *In the Backyard* (2003), for example [*right*], consists of a laptop computer on which a screensaver displays images of the construction of a dam. Next to the computer's keyboard is a tea cup. Out of the teacup comes a blanket with long embroidery threads. The work aims to assert that the art object, because it has its own language and form of expression, has a voice in society.

Always There
2000
wasp, thread
14 x 6cm

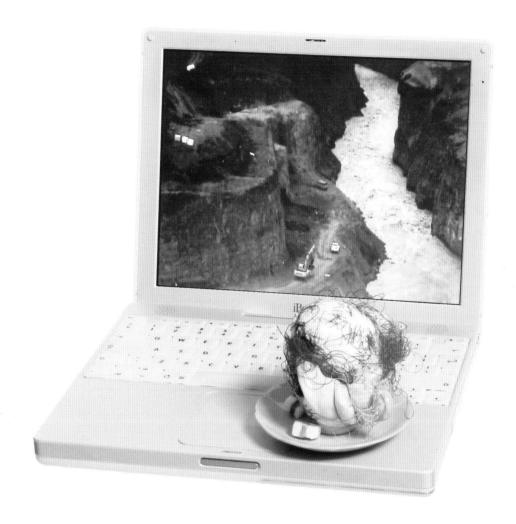

To connect earth and place – culture and experience

In the Backyard
2003
laptop, video as screen saver,
coffee cup, linen, sugar, thread
25 x 34 x 25cm

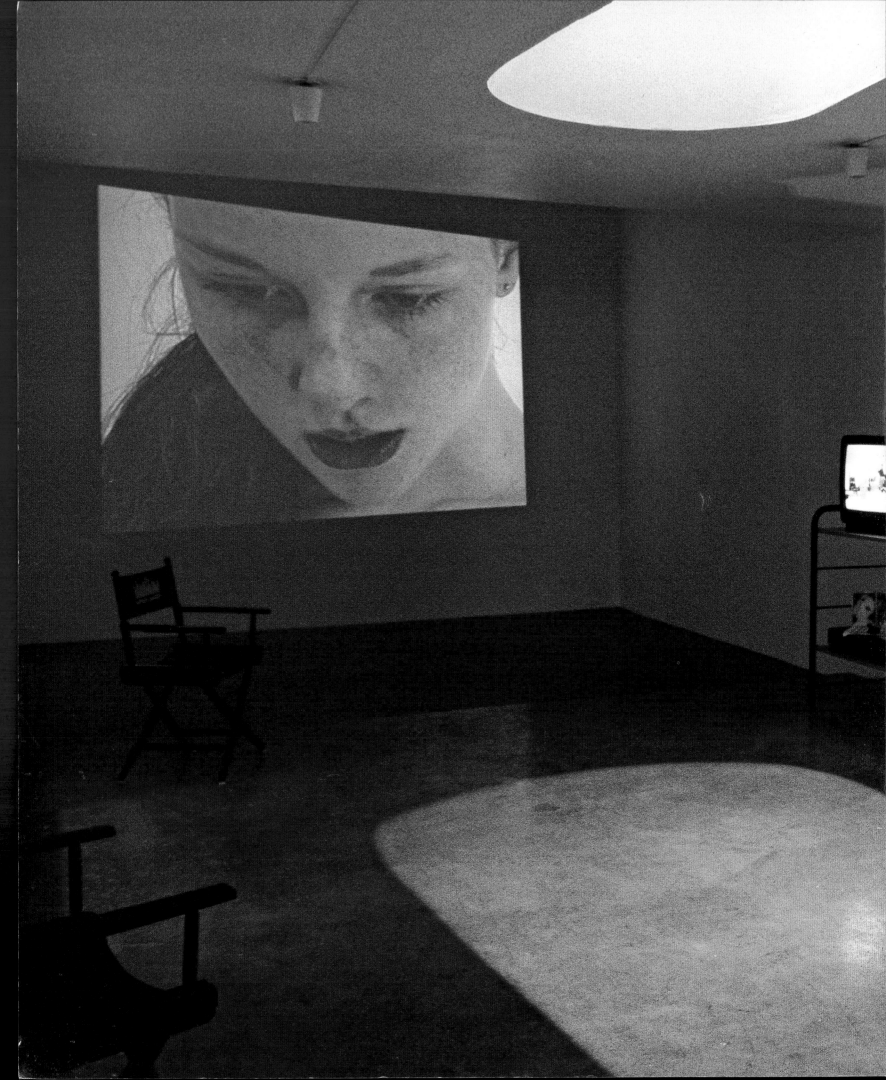

One of art's functions is to recall that which is absent, something one cannot pin down but at the same time you know that it is controlling your life.

Borders
2000
video installations,
domestic objects
variable dimensions
(see also p 76)

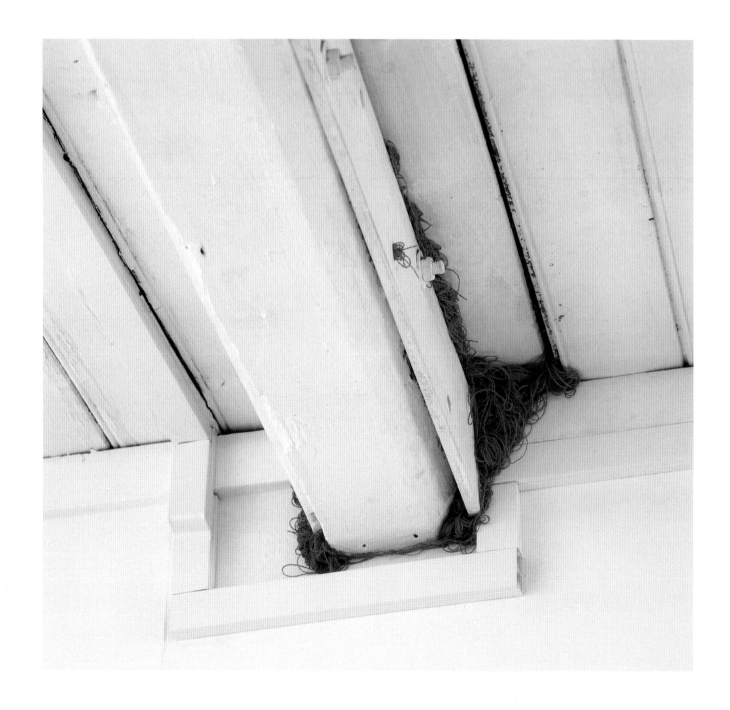

Untitled
2001
thread
variable dimensions

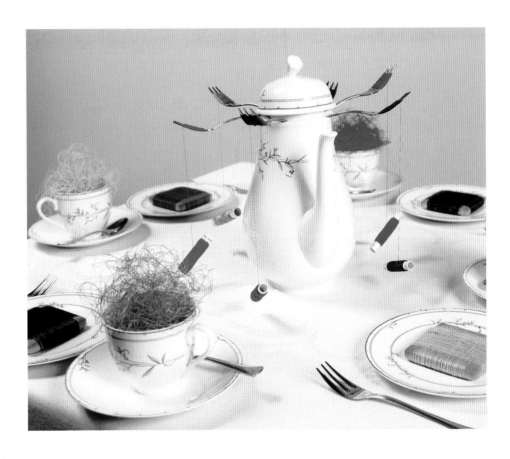

A routine action that gets out of control and consequently becomes a threat; a grip that fails, and emotional energy is released.

Variations Tilbrigdi
1995
table, tablecloth, coffee set,
thread, forks, sugar, photographs
variable dimensions

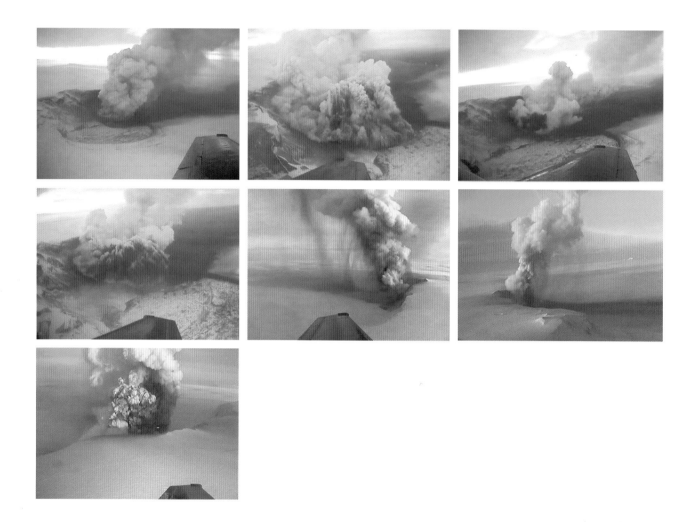

I believe that, somewhere in the space between emotions and technology, lies unharnessed energy, and a major part of my artistic struggle is involved with trying to find a suitable visual form of expression for this energy.

Borders (detail)
2000
video stills
Grìmsfjal Vatnajökull, Iceland
volcanic eruptions, 1998

Born 1957, Vididal, Iceland

Atelier Reykjavik, Iceland

www.annalindal.com

Education

1975-1978	College of Trades, Reykjavik
1981-1986	The Icelandic College of Art and Craft, Reykjavik
1987-1990	The Slade School of Fine Art, University College, London

Exhibitions

2004	Akureyri Art Museum (solo), Akureyri, Iceland
	Hamburger Kunsthalle, Hamburg, Germany
	Reykjavik Municipal Art Museum, Reykjavik
2003	The National Gallery of Iceland (solo), Reykjavik
	Art 34 Basel, Art Unlimited, videoteque
	Reykjavik Municipal Art Museum, Reykjavik
2002	Basel Art Fair – Art & Public (Geneva)
	Musée de la Ville de Luxemburg
2001	Palazzo Municipale Morterone (solo), Italy
	Art & Public (solo), Geneva, Switzerland
	The Living Art Museum (solo), Iceland
	Milan-Europe 2000, Milan, Italy
	Gallerí Sævars Karls (solo), Reykjavik
	Kwangju Biennale, Kwangju, S. Korea
2000	'Retrospective' (solo), The Reykjavik Culture Centre

Collections

Art & Public, Geneva

Malmö Konst Museum, Malmö, Sweden

Reykjavik Municipal Art Museum, Reykjavik

The Living Art Museum, Reykjavik

The National Gallery of Iceland, Reykjavik

Gävle Kulturcommune, Gävle, Sweden

Hamburger Kunsthalle, Hamburg, Germany

Professional

2000-	Professor, Iceland Academy of the Arts

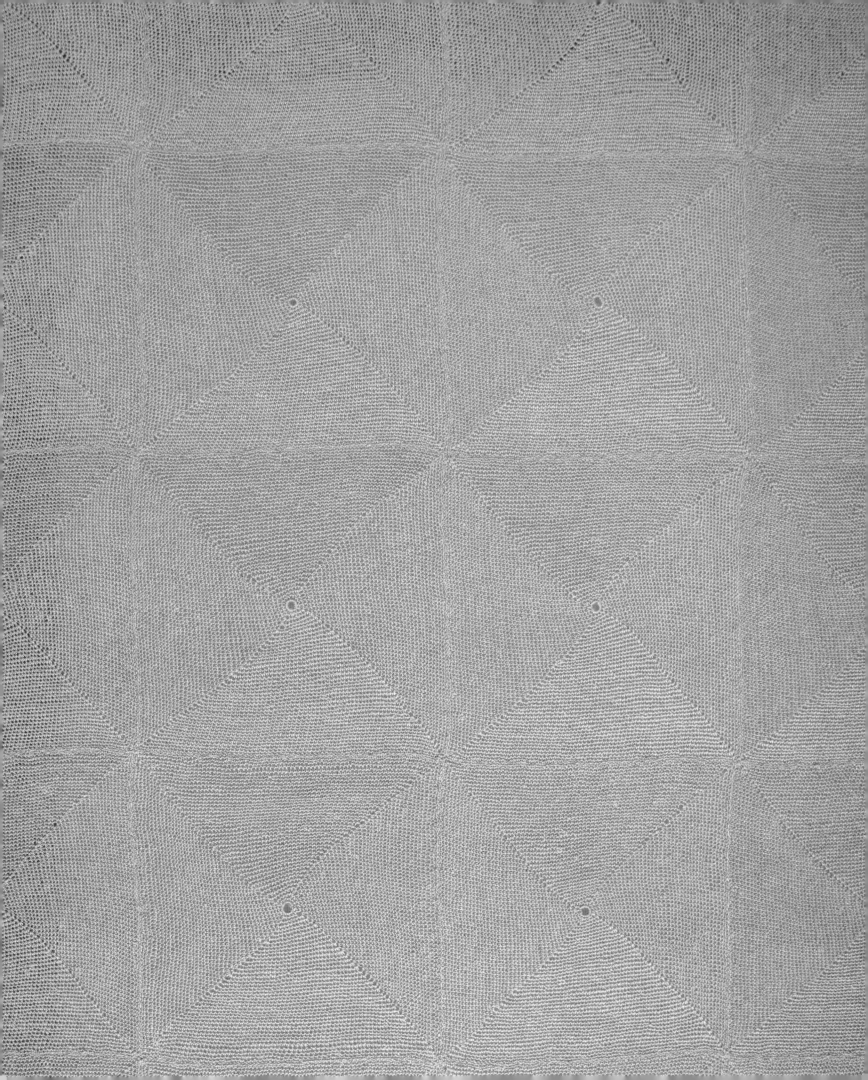

Hildur Bjarnadottir

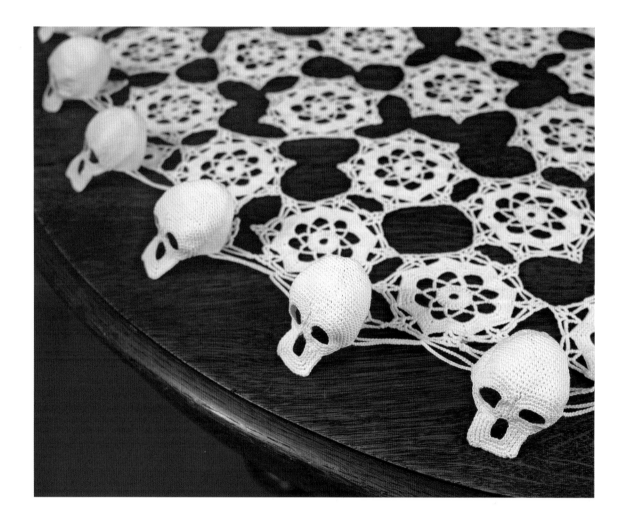

*I try to pay due respect to the craft tradition of my ancestresses
while still working with critical ideas.*

left:
Reconstructed Canvas III
(detail)
2004
crochet belgian linen
75 x 75cm

above:
Untitled (detail)
1998
crochet cotton yarn,
wood table
7 x 128 x 128cm

I remember knitting on the front lawn of our house when I was maybe five years old, my mother sitting in a chair, teaching my sisters and me how to knit. After that we knitted every chance we got. My father told us there was a law against knitting or crocheting in a car, bus, airplane or a train, since it would be dangerous to slam on the brakes, with all those needles flying around. For many years, I believed that all the people sitting on buses would be knitting if there were not a law against it.

My mother was a children's teacher of textile crafts at the local elementary school. Both of my grandmothers made textiles, and I have two sisters who remain involved with textiles, one who knits, the other a professional dressmaker. But one thing my mother did not teach me was to follow patterns. Everything I made, I had to design myself, and I was allowed to make anything I wanted. I didn't need to follow anyone else's rules, I could make up my own. I think I have carried this over into my art.

My mother often took me along with her to museums and galleries to look at art, usually textile art. I grew up thinking that all museums contained mostly textiles, and that when people talked about art it was textiles they were talking about. I remember going to a big exhibition at The Reykjavik Art Museum, around the age of nine, and seeing a piece that I still remember today: it was a knitted picture with a figure in the foreground and a seascape in the back; it was padded so the image protruded. I knew absolutely how this picture had been made: it was knitted, and the forms were made by adding or subtracting loops. I knew I could make that piece, or something very similar, but expressing my own images and ideas.

Instead of making traditional textiles, my orientation became conceptual. I would often use traditional methods, but follow my own rules for each piece. In some ways, I work contrary to everything I learned during my upbringing in Iceland and my subsequent studies at the Textile Department of the Icelandic Arts and Crafts College. I was taught to make useful and beautiful objects, but I wouldn't and I don't.

Re-rubber
1992
car tyre inner-tubes,
woven on a loom,
fishing line, metal frame
129 x 178cm

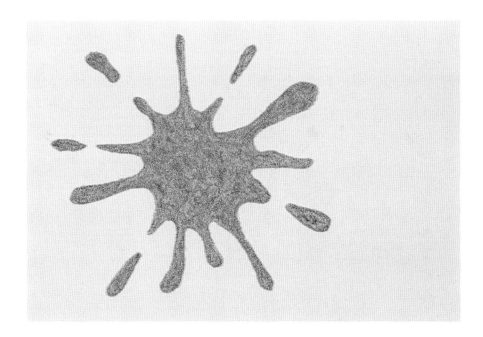

In some ways, I work contrary to everything I learned during my upbringing in Iceland and my subsequent studies at the Textile Department of the Icelandic Arts and Crafts College. I was taught to make useful and beautiful objects. But I wouldn't and I don't.

top:
Fairy Puke
2003
velvet pile embroidery,
cotton yarn
76 x 76 cm

right:
Untitled
2001
woven 4kg fishing line
each 32 x 22cm

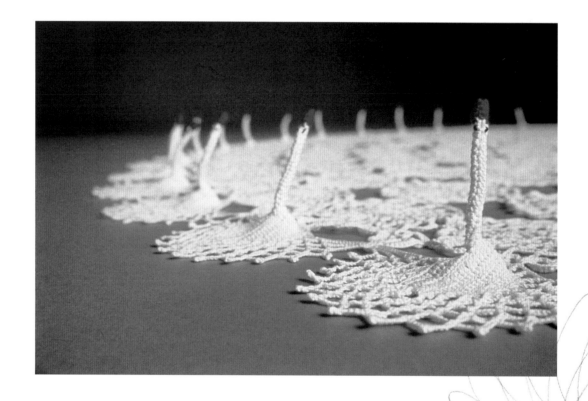

Swanhildur (detail)
1997
crochet cotton yarn
7 x 198 x 198cm

The Yarn Twirler Drawings
2002
pencil on paper
28 x 21cm

The Yarn Twirler
2002
video

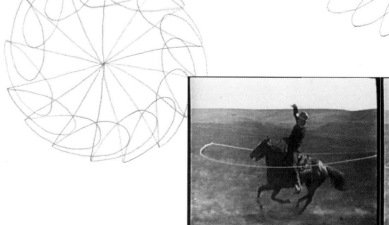

On the other hand, most of my work is emphatically hand-made, and producing it is very time-consuming. My pieces often resemble functional art-crafted objects. The handmade, craft aspect of my work is often confusing since it gets lost in a multitude of 'fine art' references, references to painting and to sculptural traditions. It seems, at first glance, to be situated midway between craft and fine art but in presentation and conceptually, my pieces certainly stand far from craft traditions.

As in *Reconstructed Canvas III,* such a lot of work was involved in crocheting little square doilies together to make the canvas that it took almost a year to produce and I feel it is consequently closer to its craft roots. In traditional crafts, a piece of work is often evaluated according to the amount of work put into making it. In the craft tradition, the amount of work is evident in the intricacy of every piece. The *Reconstructed Canvas,* however, just stays drab, the result being anything but a beautiful, useful object but rather a strange caricature of

unprimed painter's canvas; a canvas stretched like any other but signed as a craft object through the crocheting involved. The canvas is therefore both craft object and artwork, it oscillates between the categories without settling definitively in either. The canvas is turned into the focus of the piece instead of being the ground for a painting, and the meaning is embedded in the pattern of the canvas instead of spread over its surface, covering it.

In my work I reference the formative women in my past in various ways. For instance in *Swanhildur,* the piece bears the name of my great aunt who used to crochet little white doilies with five swans around them. In pieces like *Fairy Puke* and *Frippery,* I use a technique (velvet pile) that my grandmother taught me and that she still uses to make pictures. In none of my work, do I favour either the craft or the concept. I try to pay due respect to the craft tradition of my ancestresses while still working with critical ideas.

In *13 Portraits*, I present my teachers, grandmother, sisters and friends. Using a lint roller, I cleaned the clothes of friends and relatives, and the resulting lint tape is displayed, mounted on Plexiglass, as a portrait. Each takes less than 10 minutes to make, very atypical of craft. I regard this as just one way to examine textiles in a non-traditional manner, not useful, not beautiful, but meaningful.

It is debatable whether this is a completely abstract portrait of a person or whether there is a different visual connection to be made. Is our selection of what colours to wear completely random? Whether we own a cat or a dog or have dark hair or blonde?

13 Portraits
top left: Thora Sigurdardottir
top right: Gudrun Bjarnadottir
2003
lint roller tape
each 15 x 10cm

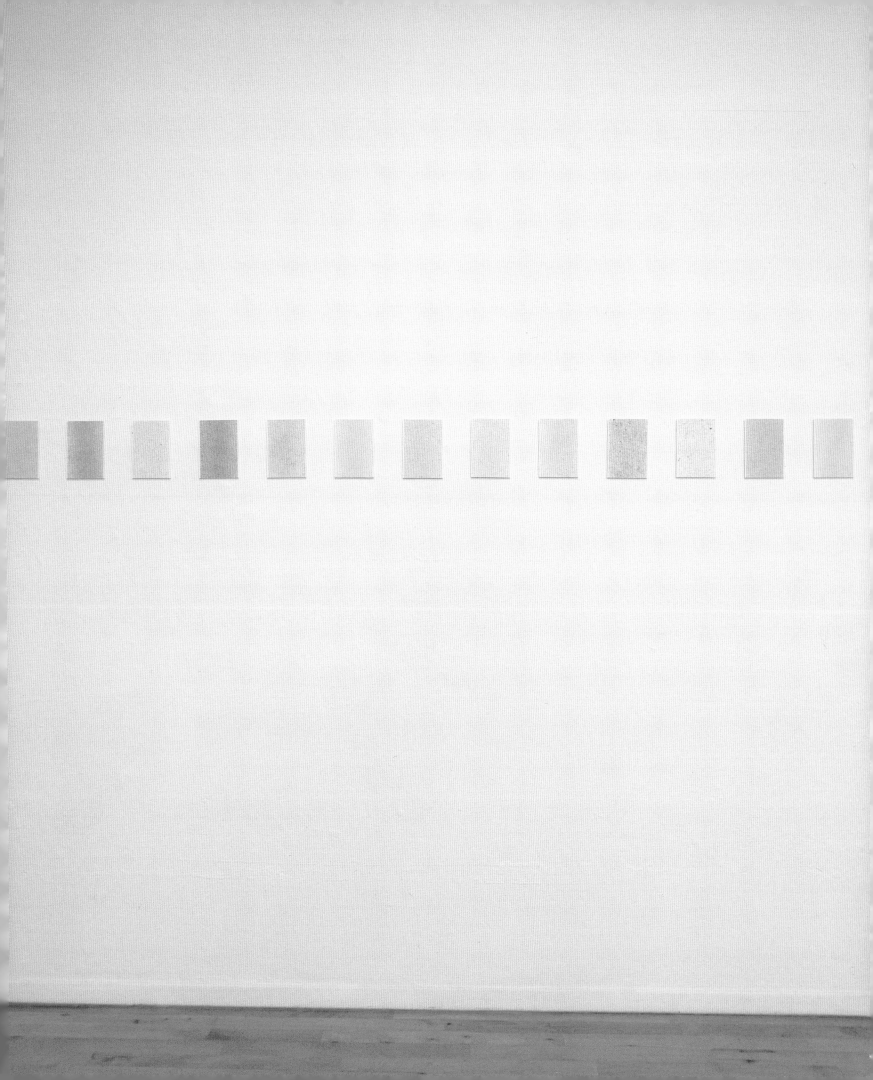

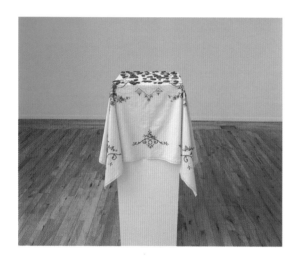

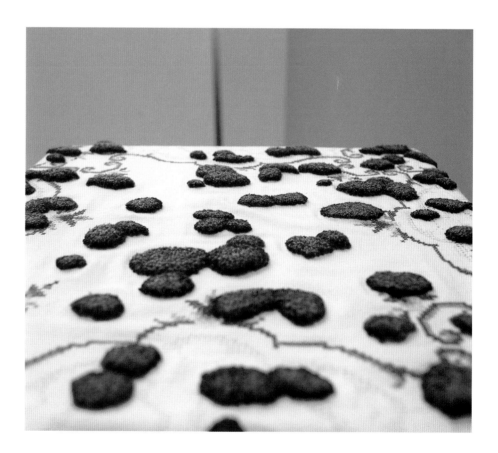

Frippery
2004
velvet pile embroidery on a table cloth
153 x 153cm

Born	1969, Reykjavik, Iceland
Atelier	Reykjavik, Iceland
	www.hildur.net

Education and Awards

1989-92	The Icelandic College of Arts and Crafts, Reykjavik
1994-97	Pratt Institute, New Forms Department, Brooklyn, New York
2000-4	Various salary grants, Icelandic government, Reykjavik
	Award and grant, Penninn Art Foundation, Reykjavik
2001	The Oregon Biennial, Juror Award, Portland, Oregon, USA
2002	Myndstef, Individual artist project grant, Reykjavik

Exhibitions

2005	Pulliam Deffenbaugh gallery (solo), Portland, USA
	The Boise Art Museum (solo), Boise, USA
2004	'Work(s)' (solo), ASI Art Museum, Reykjavik
	'Under 40', Icelandic Art Museum, Reykjavik
	'Happy art for a sad world', Spike Gallery, New York
2003	'Streaching Canvas', Pulliam Deffenbaugh Gallery (solo), Portland, Oregon
	Ferdafuda, Reykjavík Art Museum, Reykjavik
	'Ulterior Motive', Marylhurst University, Portland, Oregon, USA
	Pins and Needles, John Michael Kohler Arts Center, Sheboygan, USA
	The Wild Wild North, CityScape Community Art Space, Vancouver, Canada
	'18 Women', CCC Art Center Gallery, Astoria, Oregon
2002	'The Yarn Twirler' (solo), Gallery Corridor, Reykjavik
2001	Contemporary Skeins, Contemporary Crafts Museum, Portland, Oregon
	Oregon Biennial, Portland Art Museum, Oregon
	Domesticity, The Waiting Room, Minneapolis, Minnesota, USA
2000	Weavings and Things, Marylhurst University (solo), Portland, Oregon

Collections

2002	Francis Greenburger Collection, New York, USA
2000	The Reykjavik Art Museum, Iceland
	The Icelandic Design Museum, Iceland

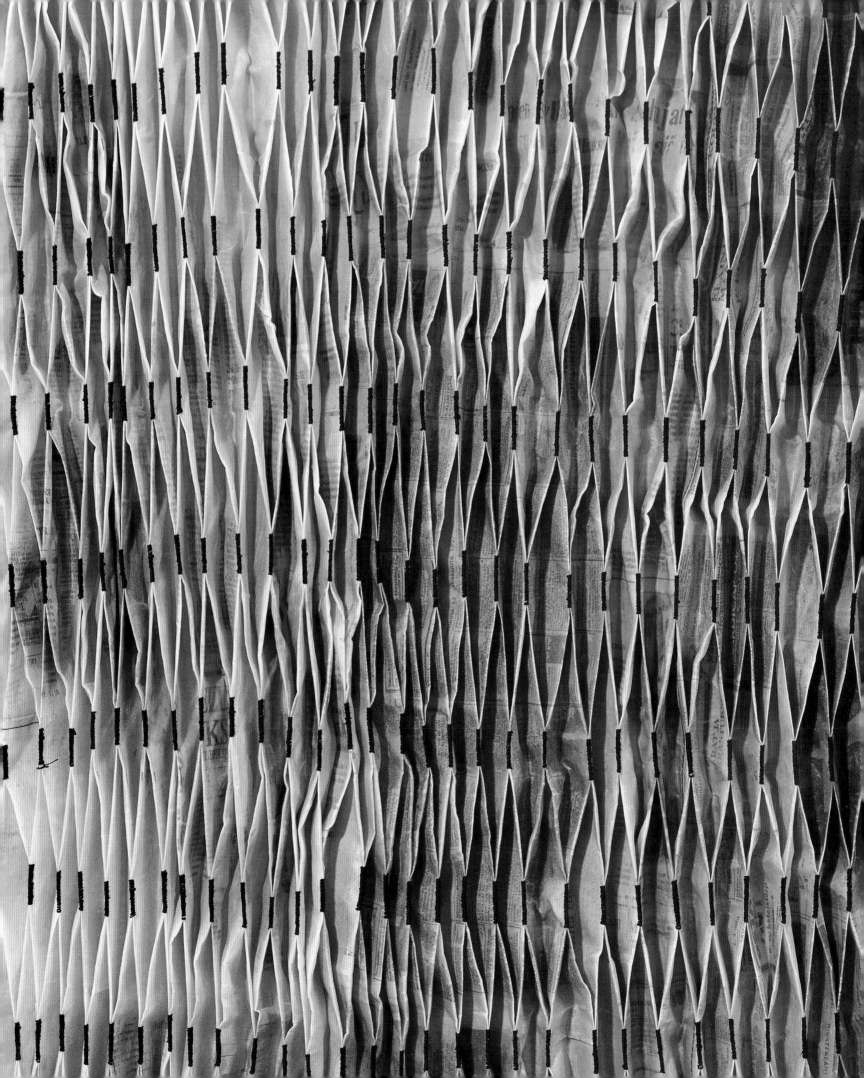

Piila Saksela

*Whatever the material you are confronted with, it is already dead –
the flax has been cut, the lamb shorn and the silkworm has offered
up its silk. All these diverse materials need new life breathed into
them, they need be recreated in a new form.*

left:
Ninive II (detail)
2002
synthetic silk, newspaper,
sewing thread
stitching, smocking
240 x 70 x 15cm

above:
Orlando
2001
steel, rust
knitting
40 x 35 x 25cm

In my early work I was enchanted by the structural potential of the textile world. It was as if miracles unfolded from the loom. Patterns and structures evolved, based on simple predetermined fractal rules, permitting endless variations in size, colour and texture. The figurative world thus created, replicated itself from within the safe confines of the warp and weft. I felt a close kinship to the community of weavers, a profession with centuries-old traditions. I was engaged in something that was easy to combine with the necessities of everyday family life and its surroundings. I believed that this would all continue and I devoted many years to my looms.

But somehow it did change. I began to feel a need to create textiles which moved beyond the capabilities and techniques governed by the warp and weft. I yearned for space, for three dimensions, for new materials, for freedom from structural restrictions. At the same time as I felt attracted toward glittering new opportunities, I also felt very fearful. How many catastrophes might lie ahead of me down this precarious and untrodden new path! How long would it take to gain a sure foothold on this new journey?

Whatever the material you are confronted with, it is already dead – the flax has been cut, the lamb shorn and the silkworm has offered up its silk. All these diverse materials need new life breathed into them, they need be recreated in a new form. But bringing one's own studio to life is an arduous task. Just as the writer fears the blank page, so it feels as if all originality will flee at any moment, it will slip through the fingers at the very first touch, in a sort of taunting dance, curtains swaying, sails flapping, flags flying.

But, little by little, through trial and error, the beginnings of a new style began to take form. A sewing machine was employed to replace my faithful old looms. It took years of searching, during which countless pieces were born with an astonishing variety of strange behaviour. Shrunken, wrinkled, wizened, miscoloured; pieces simply unfit to hang in any shape or form! Finally, a series of patterns started to emerge, and they gradually linked to form part of a larger continuity. Working with one piece, I would notice how a plan for the next was born.

The technique in my recent works involves the preparation of synthetic silk with a combination of oils and lacquer to enhance the colour and translucency. I put this on top of selected tissues or papers, which, when detached, transfer their colours and markings to the material. The subsequent orderly structuring is done by hand using the age-old smocking technique of Hungarian national dress.

Textiles are understood by each and everyone of us from our own very personal experience. In one form or another, textiles are with us throughout life. One does not need to speak of any particularly unique textiles to admire their beauty – textiles drift before our eyes everywhere we look, from faded rags and carefully patched garments, to large pieces on walls or awnings, and made of such a variety of materials, small collections of threads, hemp, feathers... a truly bewildering richness to choose from!

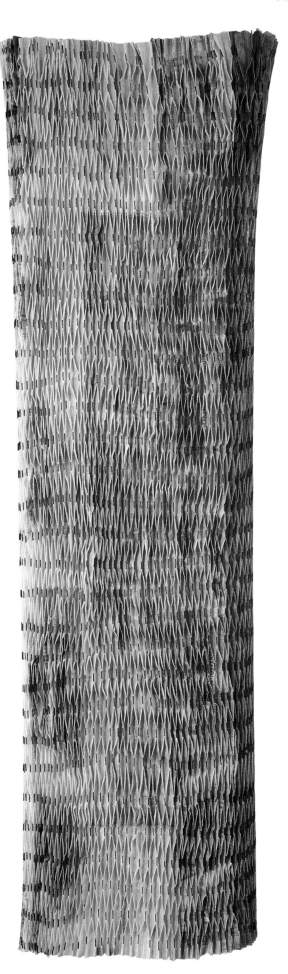

The technique in my recent works involves the preparation of synthetic silk with a combination of oils and lacquer to enhance the colour and translucency. I put this on top of selected tissues or papers, which, when detached, transfer their colours and markings to the material. The subsequent orderly structuring is done by hand using the age-old smocking technique.

Ninive II
2002
synthetic silk, newspaper,
sewing thread
stitching, smocking
240 x 70 x 15cm

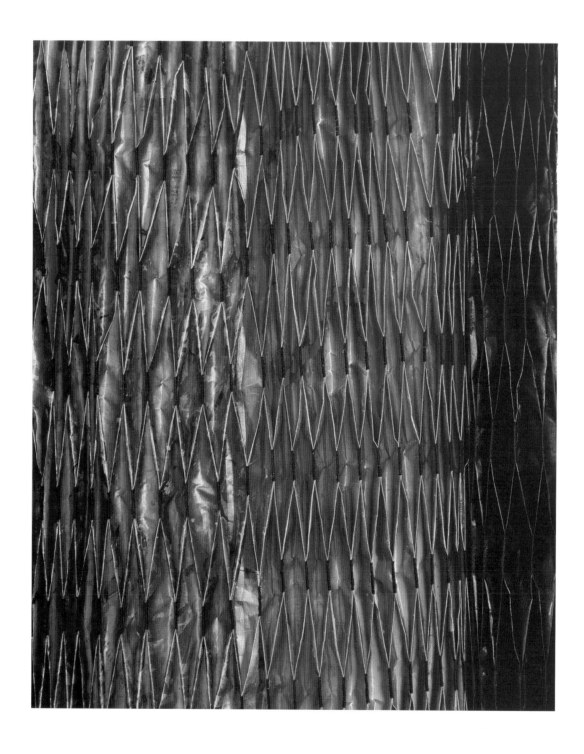

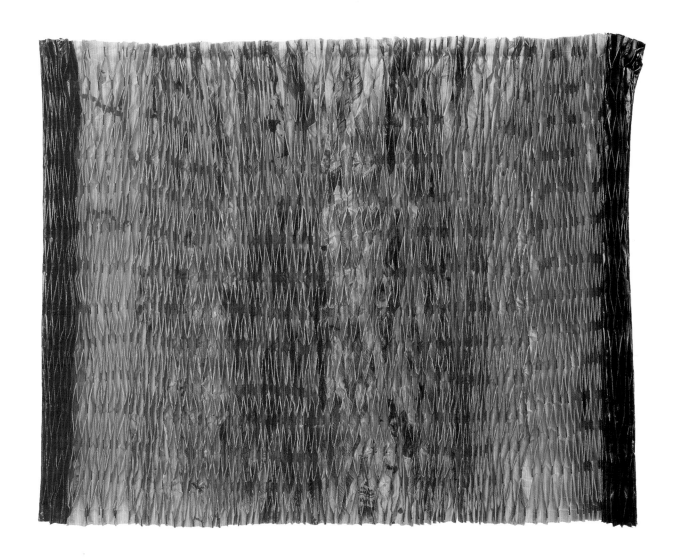

Land Ahead
2000
synthetic silk, newspaper,
sewing thread
stitching, smocking
125 x 160 x 15cm

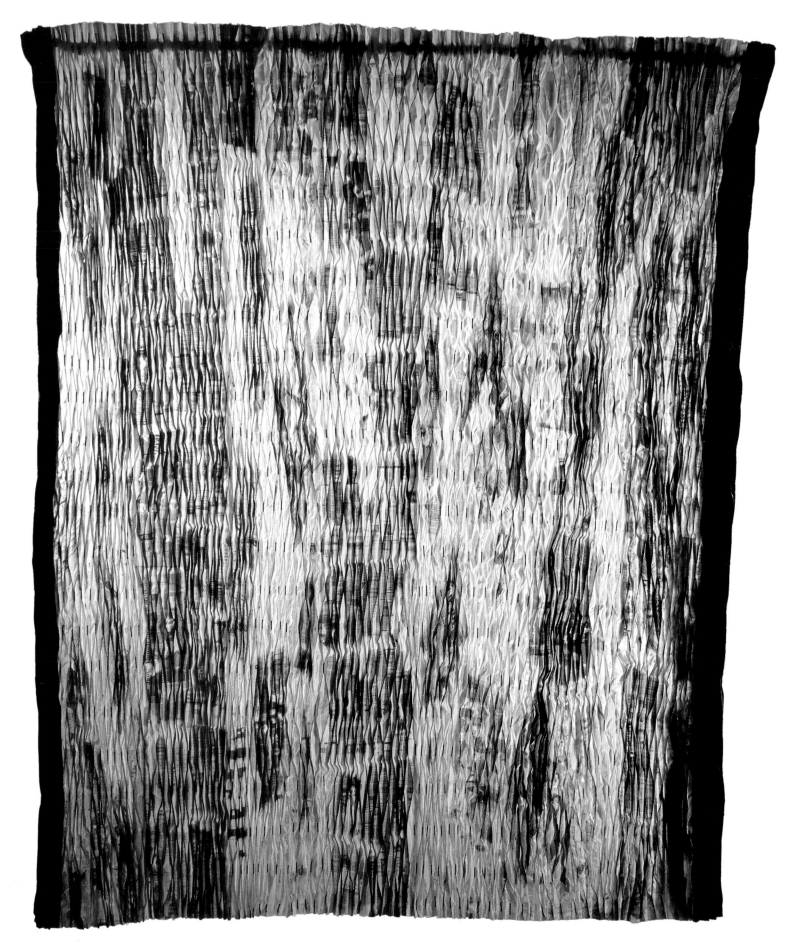

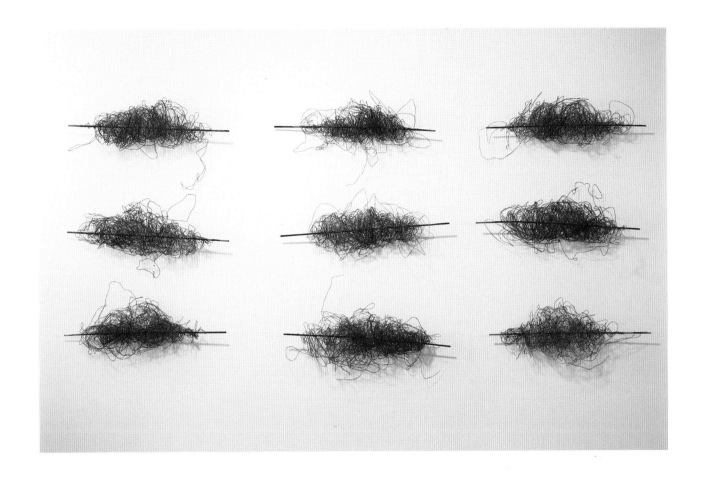

I most wish that light, time and fortuity should be present in my work. I feel a strong desire to capture more light in my work; and I draw on and reformulate deep layers of memory. By fortuity I mean spontaneity, freshness, a certain unintentional quality!

left:
Working in the Garden
2000
synthetic silk, newspaper,
sewing thread
stitching, smocking
220 x 180 x 15cm

above:
Circling
2001
wrapped steel,
rust, wood
120 x 245 x 20cm

Textiles are understood by each of us from our own very personal experience. They drift before our eyes everywhere we look, from faded rags and carefully patched garments, to large pieces on walls or awnings, and made of such a variety of materials, small collections of threads, hemp, feathers... a truly bewildering richness to choose from!

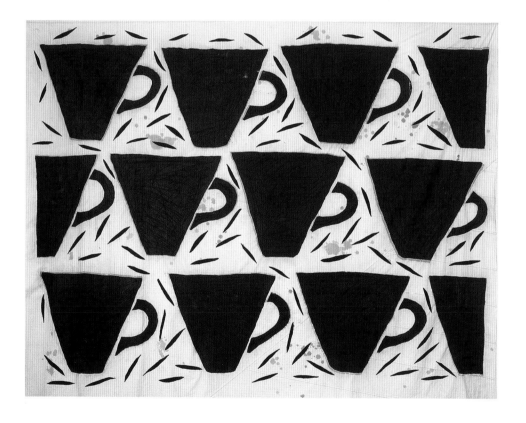

Untitled
1993
sail cloth, felt
appliquè
210 x 290cm

Born 1938, Helsinki, Finland
Atelier Espoo, Finland

Education
1959 University of Industrial Arts, Helsinki

Exhibitions
2001 Gallery Johan S (solo), Helsinki
1999 'Transparent Planes', Textile Kultur Haslach, Haslach, Austria
1998 International Triennale of Tapestry, Lodz, Poland
1996 3M, Savonlinna Art Museum, Savonlinna, Finland
1992 'Le Primitif Noble', Institut Finlandais, Paris
1991 Triennale of Finnish Textiles, Tampere Art Museum, Tampere, Finland
1990 Arts and Crafts, Gallery Kluuvi, Helsinki
1985 Gallery Kellari (solo), Helsinki
1978 Library of Espoo (solo), Espoo
1977 Gallery Kluuvi (solo), Helsinki (with Esko Pajamies)

Collections
 National Museum, Stockholm
 Art Collection of the State of Finland
 Jenny and Antti Wihuri Foundation
 Saastamoinen Foundation
 Works in public buildings in Helsinki, Espoo and Tampere

Wagle & Lovaas

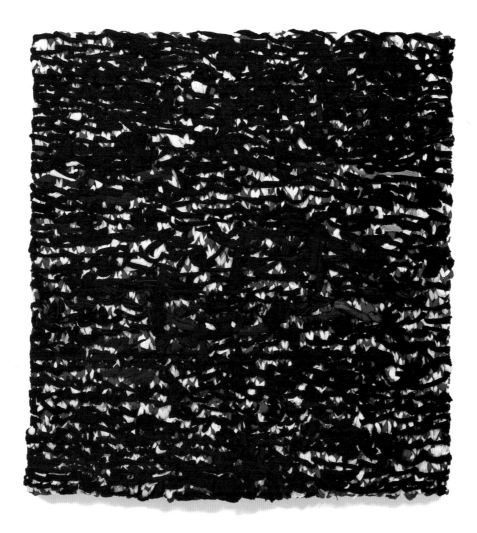

Nylon stockings conjure up associations from the past and tell hidden stories. We have for many years been playing with their subtle variations in colour and texture, and feel that we have as rich a palette as any painter.

left:
Pattern tapestry
1994
suits, nylon stockings,
blockprint
323 x 325cm

above:
In the Rosegarden
1998-99
woolen blankets,
nylon stockings
200 x 187cm

For many years the principal theme of our projects has been surfaces: the nature of the surface, the sensuousness of the surface, textures, weaves, light and shadow, pattern, repetition. Our concern is to create a form of expression that relates to the whole, and one that interacts and communicates with architecture.

We started to work together while we studied at art school, in 1981. Our work is based on total cooperation, we sign our pieces with both names and it is impossible to distinguish the work of one person from the work of the other. We work together through all the stages in the process.

When we work in a field, we try to innovate, to see things in a new way, aiming to influence thought. We have a system for working where we start by doing research, then we develop our background knowledge and experience of a subject, be it a textile, technique, craft, material, ornament or pattern.

When we create a visual statement, we seek to inform about any influences or links.

Before our work with nylon stockings, for many years we made quite strict, clean pieces using folded plain cotton. Then, we developed a strong interest in used materials, such as woollen army blankets, mens' suits, socks, rainwear, bubble-jackets, knitted clothes and nylon stockings.

Our work is based on total cooperation ...
There are many strong precedents for artistic
collaboration: the French architect Le Corbusier,
for example, worked with his cousin for a period.
He said: "Two people who understand each
other can do as much as five people on their own".

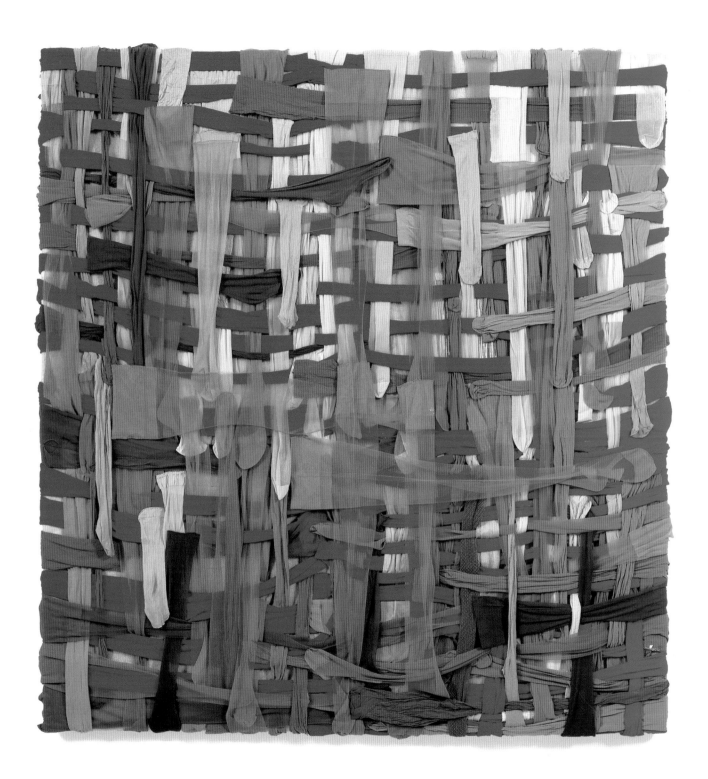

Shimmer
1999
woolen blankets, nylon stockings
170 x 160cm

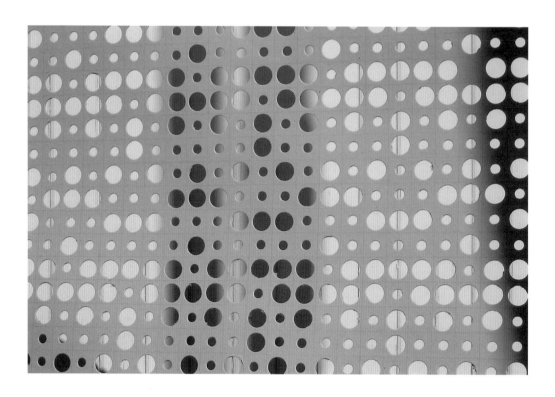

Opera House Project, Oslo

We consider ourselves artists and our works artworks, though we have become involved in a project that challenges this assertion by its sheer scale. In dialogue with the architects, we were recently engaged, to dress the facades of the New Oslo Opera in light grey anodised aluminium plates. For the development of this element, the architect wanted artists to be incorporated in the architectural planning team.

Originally, the assignment was to clad the fly-tower, the technical rooms on the roof and the workshop block of the Opera House at Bjorvika with perforated metal plates of anodised aluminium. Priority aspects of the project were to be the development of the perforation pattern, the pattern modules and the tessellation pattern for the plates. The task has quite strict limitations and ornament is our main concern.

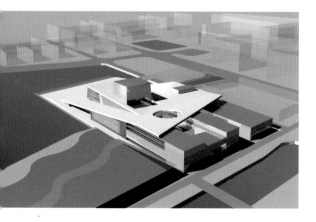

Architectural model
by Snohetta
2004

We started out the project by doing a lot of research, to establish all the alternatives. The difficulty of transforming our ideas to the monumental building façades meant that we spent a lot of time trying to understand the task, the idea of the building, the expression of the building, its dimensions, etc. Dialogue with the architects was also involved and discussions, making sketches and studying aspects of architecture.

We have developed a scheme using an expressive style that will clad all of the building's external metal façades consistently. Our idea is to avoid defining some areas as more important than others but rather to envelop everything in the same mantle, using a pattern that will follow the building up, down, around the walls and over the roof.

Through all the stages of development, the idea has focused on both the whole concept and on the detail together. Step by step, we have built on the basic idea using a weaving pattern from the crafts tradition.

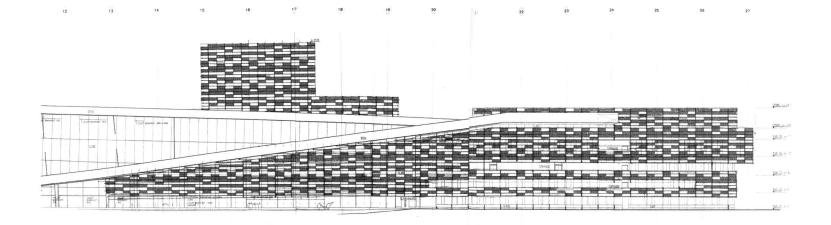

South façade
sketch

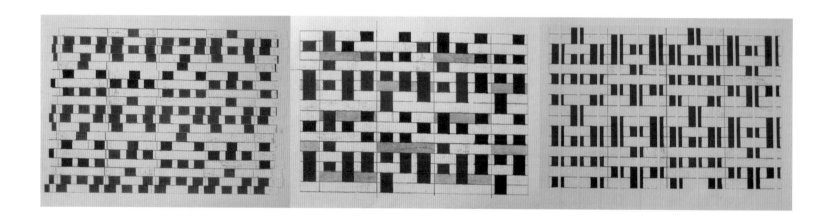

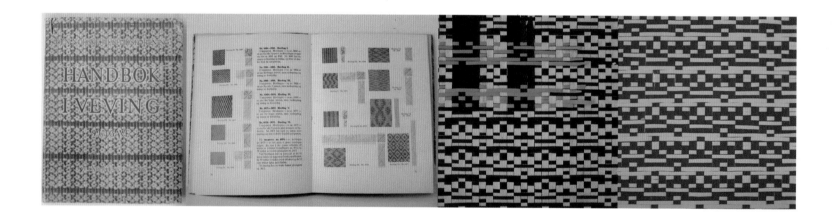

above:

Sketches

different ways to compose
the pattern

below:

**The original pattern is from
a weaving book** *Handbok i
veving,* 9th edition, Den
Norske Husflidsforening by
Caroline Halvorsen, publ. J.W.
Cappelen Forlag, 1951, 1st
edition 1904.
Testing the pattern by weaving
with bands from rain cloth

We contacted a factory making perforated plates, studying their production processes, to see
if it were possible to influence the process simply and thereby to create surprising variations.
The lightweight, externally applied, perforated metal plates will constitute a cosmetic layer so
the underlying solid building will give a transparent impression. The perforations draw their
inspiration from textiles – from an old weaving pattern in the home crafts tradition. The round
threads are enlarged in scale and transposed to form large, rectangular tiles on the wall with
the threads represented by circular holes. These perforated fields will be tessellated to form
six different compositions that will ensure sufficient variation. The patterns of, deviations
from and associations with textile art will give the façade a materiality and an elegance that
we can look forward to seeing at some time in 2008. The historic collaboration of former
times between architects, artists and craftsmen has been resumed once again!

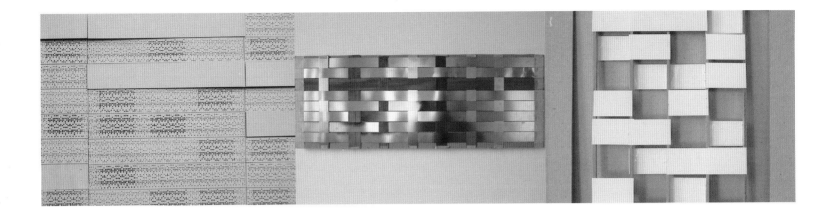

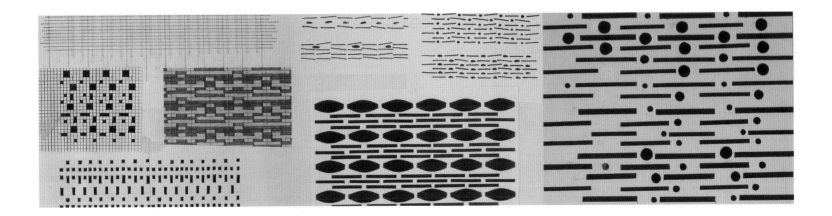

above:
Plates model 1:20
Sketches: relief, metal
weaving, surface,
construction

below:
**Sketches, drawings,
possibilities, thoughts**

*For many years the principal theme of our projects has been surfaces:
the nature of the surface, the sensuousness of the surface, textures,
weaves, light and shadow, pattern, repetition. Our concern is to create
a form of expression that relates to the whole, and one that interacts
and communicates with architecture.*

"Pattern is not something that people invent but rather something we discover within the invisible interior of the world. The entire universe consists of patterns, an endless variation of different structures that interweave to create the great totality."

Kirsten Fagerberg and Morten Skriver

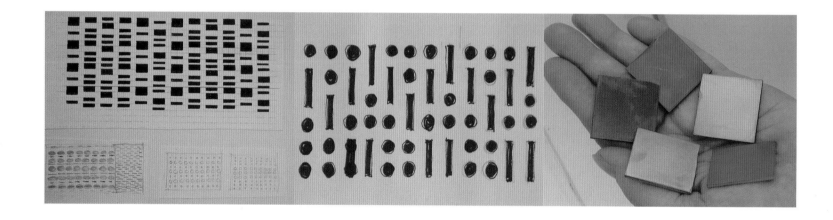

above:

Sketches
Colour samples
(anodised metal)

below:

Perforated pattern
model 1:1

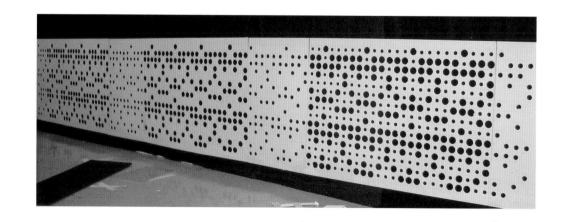

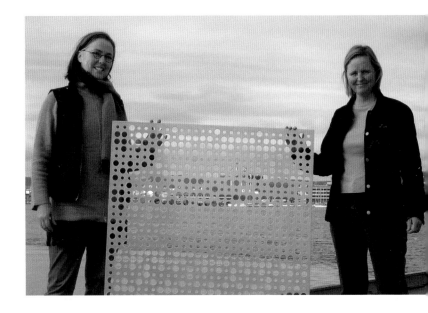

Born 1956, Kirsten Wagle, Oslo, Norway
 1957, Astrid Lovaas, Bergen, Norway
Atelier Oslo, Norway

Education and Awards

1978-82	National High School of Art and Design, Oslo, Textile Art
1981-	All work in collaboration
1982-02	Grants from public and private foundations
1997-	Annual grant from the Norwegian Government

Exhibitions

2002	'Konkret', Non-figurative Art in Norway 1920-2000
	SOFA, Chicago, USA
2001	SOFA, New York
2000	'Hunting scenes', Kunstnerforbundet, Oslo
	Brown-Grotta Art Gallery, Connecticut, USA
	North Dakota Museum of Art, USA
1997	Textile-triennale, Tournai, Belgium
1995	Kunstnernes Hus, Oslo; Bergen Kunstforening, Norway
1983-02	Statens Kunstutstilling, Oslo

Commissions

2004	Cinema 1, Sandnes, Norway
2003	Opera House, Oslo (due for completion 2008)
2001	'Adventure of the Seas', Royal Carribean Cruise Line
1997	Main Stage Curtain at Trondelag Theatre, Trondheim, Norway
1995	Music Conservatory, Bergen, Norway

Collections

Art Collection of the Community of Oslo
Museum of Arts and Crafts, Bergen, Oslo, Trondheim, Norway
Norwegian Art and Culture Council
National Touring Exhibitions
Museum of Contemporary Art, Oslo
Norwegian Government, New Ministerial building, Oslo

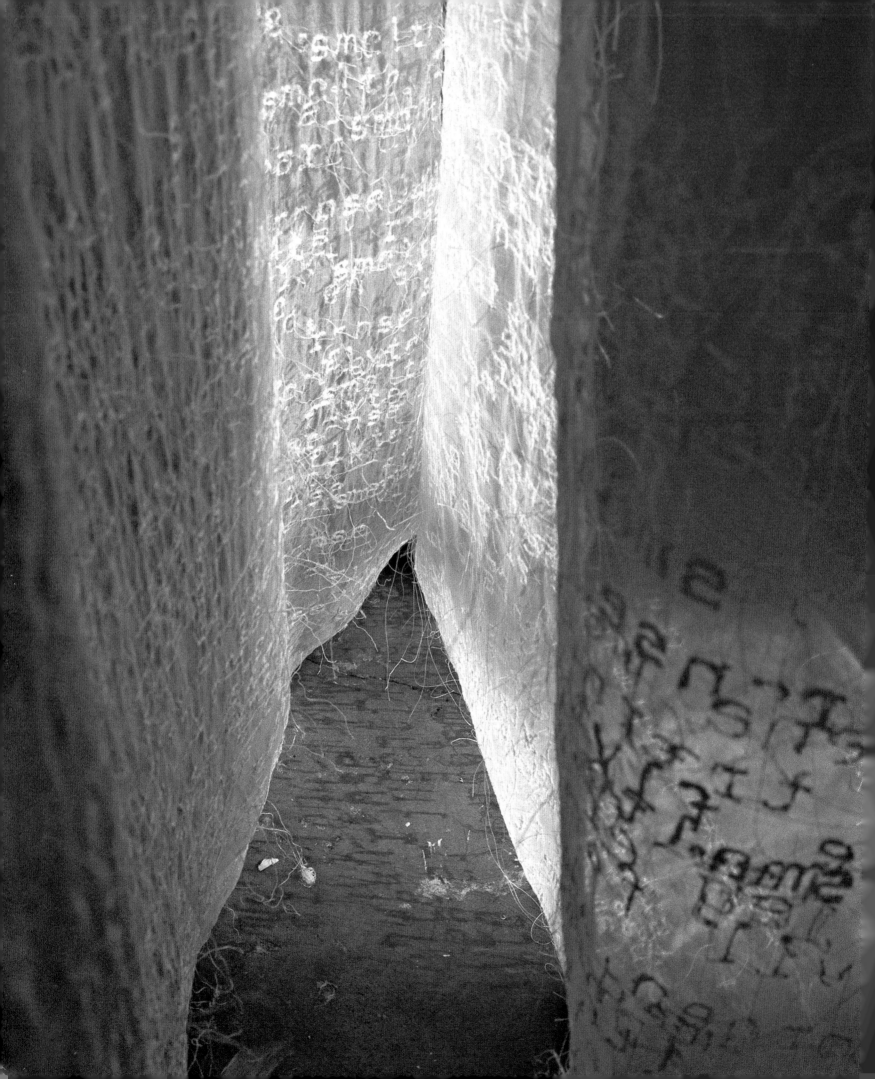

Gunvor Nervold Antonsen

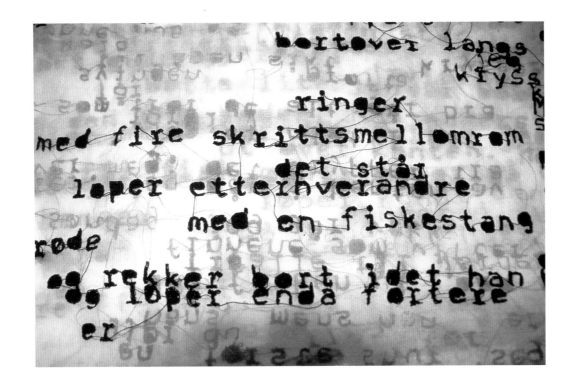

Through text and material, I explore human vulnerability. Feelings of submissiveness, frailty, even victimisation, alternate with periods of angry resistance, a tense revulsion to the very thought of communicating with others.

left:
Ventende. I mellom (detail)
2003
embroidery on silk
320 x 100cm

above:
Disturbances (detail)
2001
embroidery on silk
300 x 220cm

My interest in textiles as a medium for my art is based on textiles' capacity for containing history and personality, and their susceptibility to change and influence. For me, working with textiles is about being attuned to the distinctive character-istics of the materials.

I combine print, machine and hand embroidery on various fabrics – old and new, the important thing is that they continue to communicate. Many of my works are built up of several transparent layers – which I consider to resemble veils. When working with layers, surfaces interact and create more complex compositions with a depth of field.

Text as image, text as a vehicle for meaning, and the tactile nature of embroidered texts, are all central elements of my work. I attempt to bring about an encounter or a collision between the tactile materials, the subject matter of the texts, and the imagery; where each component part mirrors, opposes or reinforces the other. I hope the embroidered texts' surface and texture will instil in the observer a feeling of the 'incarnate' or embodied nature of text.

My work is influenced by ideas around poetry and other forms of writing and using text. Inspiration may come from graffiti or street-art, or from the unexpected outcome of an impulsive act, just as much as from any formal, published text. Text is something that never actually arrives at a real ending: syllables, words, sentences, statements, exclamations, messages... symbols which are open to innumerable interpretations.

I devise my own texts. Some are mere fragments or scraps of words in isolation; but explicit statements also appear alongside longer phrases, addressed more articulately. Since my working methods are intuitive, collage suits me well. Collage can achieve a rawer, more impulsive expression than a pre-planned work.

When working with art, I like the feeling of being hurried, not knowing exactly where I am going or what I am pursuing, I try to be both patient and eager at the same time. I make statements without knowing whether anyone is listening or not. I try to convey my position as a sceptic; questioning the beliefs and values of the society which surrounds me. Art is only one way, of many, to confront assumptions, but I believe that art allows us to move faster and further, innovatively questioning and formulating different points of view.

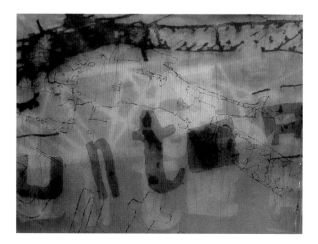

Unter (detail)
2004
embroidery on silk
74 x 100 cm

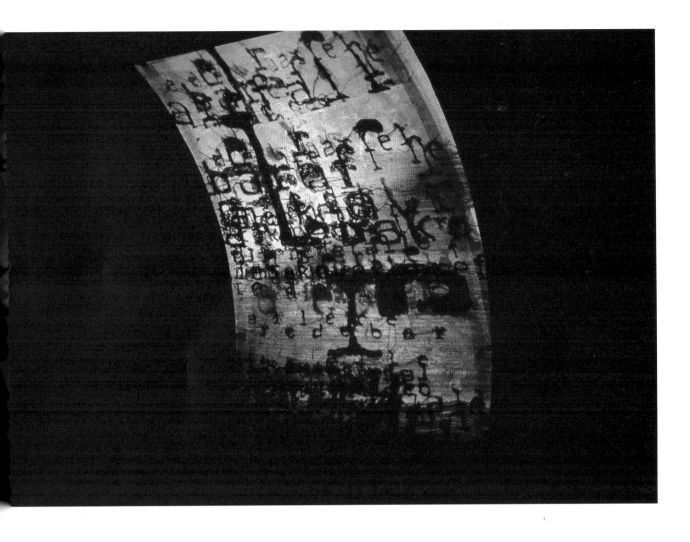

Textured Rooms
2001
embroidery and projection
variable dimensions

By projecting stills of magnified embroideries onto textiles suspended in space [*Textured Rooms*, above], a small embroidery is stretched out, extending far beyond its own original limits, and connects with its surrounding environment. As visitors walk into the room, another interaction happens as the image is projected onto them, and they become literally absorbed into the work.

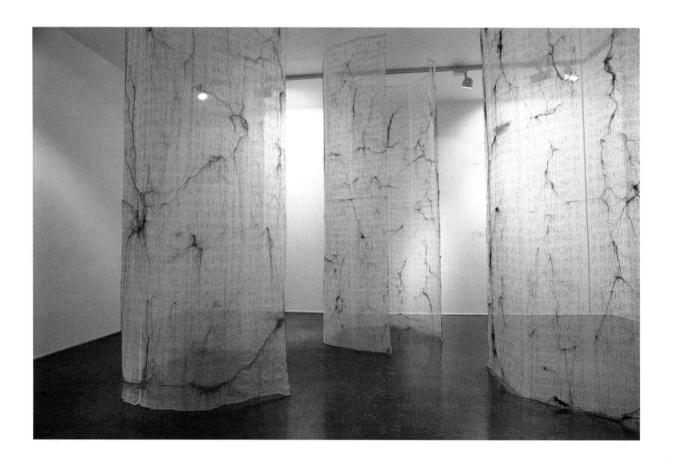

In the project *Threads of Transgression*, I use materials with
an apparently different character, but which share references
to human vulnerability. By giving the textiles different shapes
and placing them free-standing in the exhibition room, I want
them to emerge as distinct objects, reaching a size that
contrasts with the emotional content of the work.

I like the symbolism of tangles. I leave the leftover threads
from the embroidery outside my control, and they soon get
tangled up together. In the big heavy canvas, printed dark
brown, the tiny white threads announce: *A Momentary
Resistance*. These threads keep falling from the letters
to the floor, and remain forever unresolved.

above:
**Entangled, Entrapped,
Absorbed** ('Threads of
Transgression' series)
2003
embroidery on silk
3 half open circles of
300 x 300cm

right:
Entangled
(detail, 'Threads of
Transgression' series)
2003
embroidery on silk
300 x 300cm

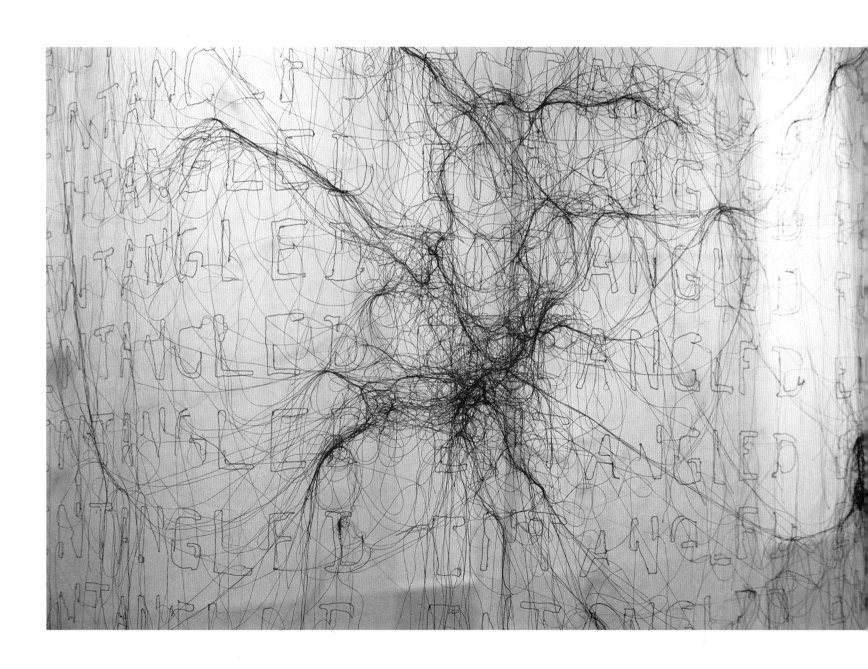

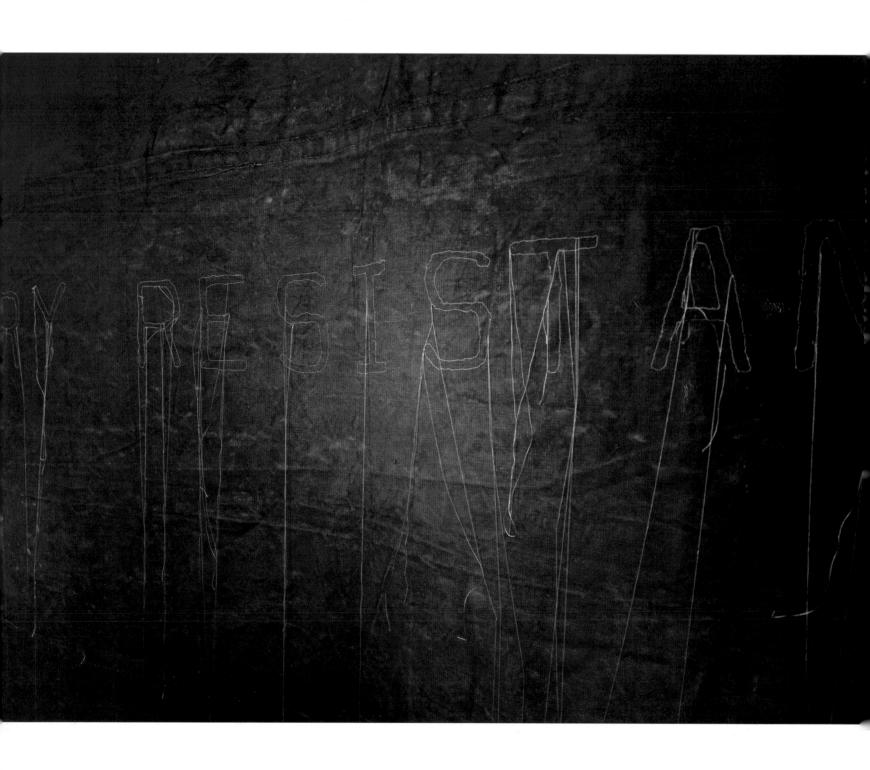

above:

A Momentary Resistance

(detail, 'Threads of
Transgression' series)

2003

embroidery on canvas

250 x 340cm

right:

Feats of Vulnerability

(detail, 'Threads of
Transgression' series)

2003

embroidered bandages

variable dimensions

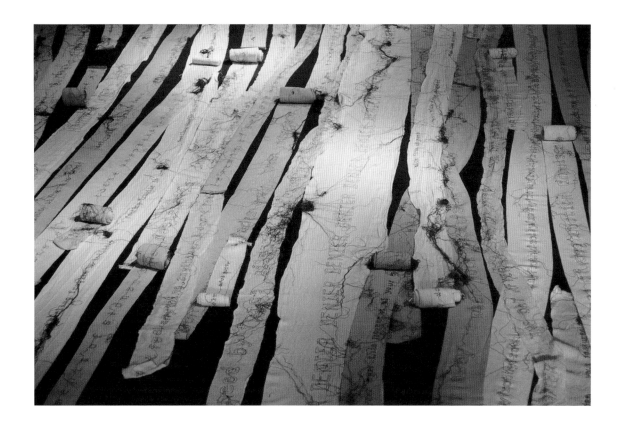

Text is something that never actually arrives at a real ending: syllables, words, sentences, statements, exclamations, messages...

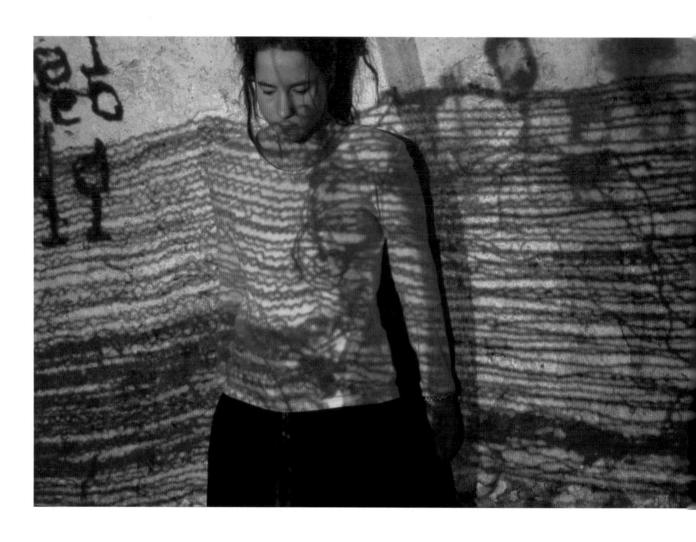

above:
Textured Rooms
2001
embroidery and projection
variable dimensions

right:
Wall-writings
2004
embroidery on silk
74 x 100cm

I like fear

Born 1974, Oslo, Norway
Atelier Oslo, Norway
www.gunvornervoldantonsen.com

the unconscious is structured like fear)

Education and Awards

1996-2001 Bergen National Academy of the Arts, Textiles Department
1998 Kunsthochschule Berlin-Weissensee, Textiles Department
2002-2005 National Scholarship for Young Artists, Norwegian Council of Culture
2003-2004 Oslo City Hall Studio for Young Artists

Exhibitions

2005 Oestfold Art Centre (solo), Norway
2004 'Threads of Transgression' (solo), Kunstnerforbundet Gallery, Oslo
2003 'Ventende. I mellom' (solo), Art Centre of Oppland, Norway
4th Textile Triennial, Uniunea Artistilor Plastici, Bucarest
'4 X tekstil', Sogn og Fjordane Regional Art Centre, Foerde, Norway
2002 Triennale Tekstil og Fiber, Oslo Museum of Applied Art, Oslo
'NTK 25aar', Telemark Countygallery, Notodden, Norway
'4 X tekstil', North Norway Regional Art Centre, Svolvaer, Norway
2001 'Art of the Stitch', Embroiderers' Guild International Exhibition, London and Birkenhead
'Tekstil i 3dje', Galleri Lista Fyr, Lista, Norway
'B+O', Haa Gamle Prestegaard, Norway

Publications

2004 'Feats of Vulnerability', Anne Schäffer, Kunsthaandverk, no.1, Norway
2001 'Norway: new work, new views', Fiberarts, no. 4, USA
'Review: Art of the Stitch', Fiberarts, no. 4, USA
'Text as Texture on Textile', Anne Morell, The World of Embroidery, no. 3, UK
'Loud is the New Silence', Halvor Bodin, Kreativt Forum, no. 1, Norway

Commissions

2004 A-Pressen ASA, Conference Centre, Lillestroem, Norway

Professional

2004- Member of The Norwegian Textile Artists Curator Committee

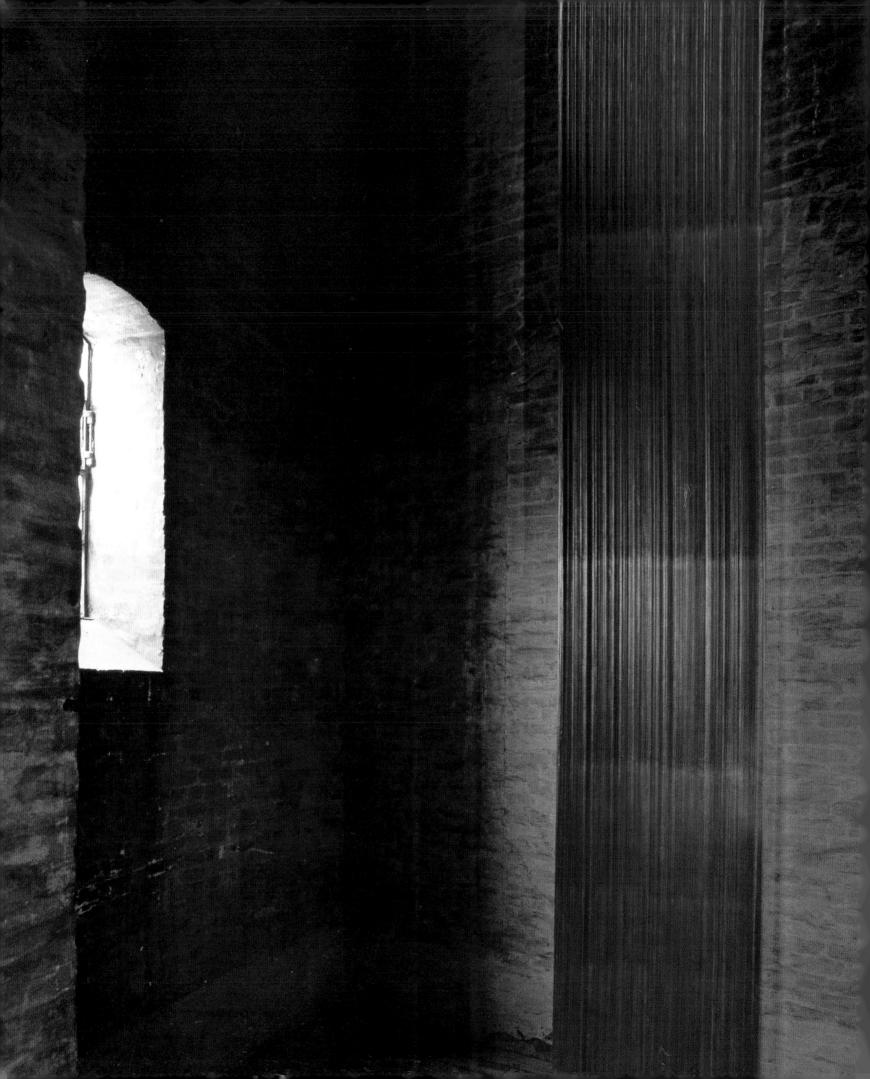

Ulla-Maija Vikman

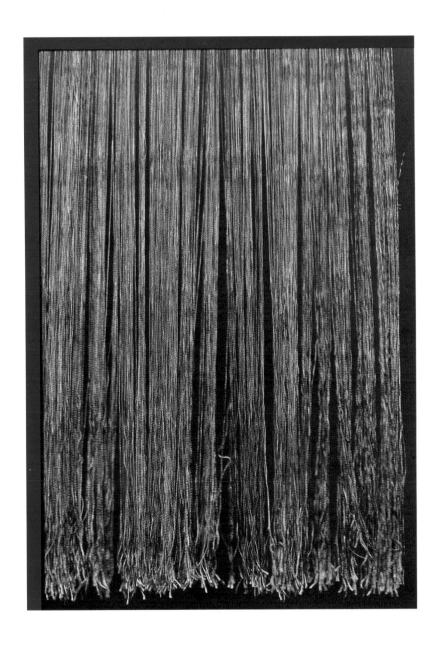

left:
Nadire
1996
viscose, painted
840 x 90cm

right:
Monday or Tuesday
1989
viscose, painted
50 x 40cm

I always hang my work at some distance from the wall so that it gives the impression of being in free fall, floating in the air. The slightest breeze or draught makes the threads move, effecting both the light and the form of the work. This quivering effect brings the piece to life within its environment.

Colour has been the principal challenge through my career. It has always been a profound source of inspiration, even before I became an artist, and now it has become a subject of great interest and depth. I started working in the 1970s in a collective workshop, where I made prints, and calligraphic paintings on silk. In Finland and internationally, this decade was a turning point in the development of modern textile art. Its tendency to encourage a new personal approach to art encouraged me to search for my own personal mode of expression.

More specifically, I was inspired by reading Jack Lenor Larsen's book *Dyer's Art: ikat, batik, plangi*. In it he has a black and white image of a South American Indian ritual cape, in which the separate bast strands were tied to a cord at the top. On the surface of the strands there was a big simple geometrical pattern. This archaic cape made a special impact on me. It felt almost as if, seeing that pattern, I heard my language for the first time.

In that spirit, I started experimenting with viscose threads. I wrapped them around a small acrylic plate to make an even surface and, using textile dyes, I painted horizontal stripes. Then I washed and released the threads, stretching them between two sticks. The result was a kind of painting that was alive, the colours performing and shimmering. The method seemed to work. I then made a two-metre warp, spread it on a table and painted it with cold reactive dyes. The next day I rinsed and fastened the threads to a wooden stick, and took the piece to a group exhibition. The hanging of the work posed

a problem of its own. After several experiments I finally decided to imitate a brush: bundles of threads were knotted at the top into a perforated wooden frame in two layers, with the thick surface of threads cascading freely into space.

I produce my fibre paintings on two large print tables, mostly in four parts. Threads stretched like a warp form a surface on which I paint like a painter on a canvas. The method still poses problems: some colours remain strong after rinsing while others fade. You can never know exactly how the colours will turn out. Seeing the result is an exciting moment. I repaint and wash two or three times to get the tones I want.

right:
Onkamo
1999
viscose, painted
150 x 130cm

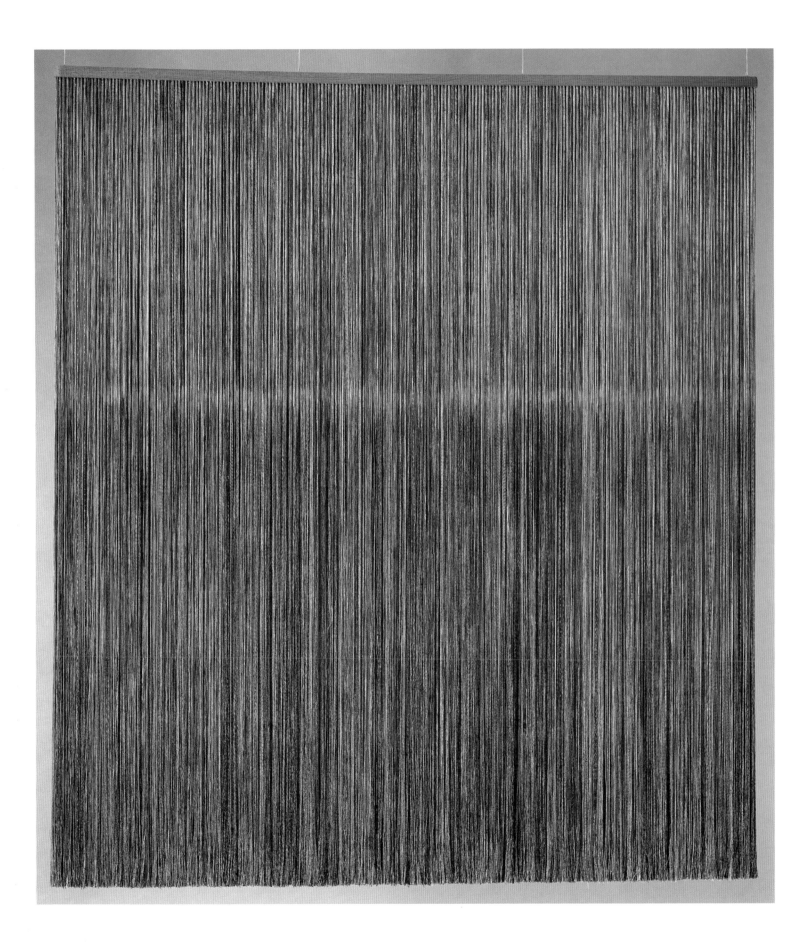

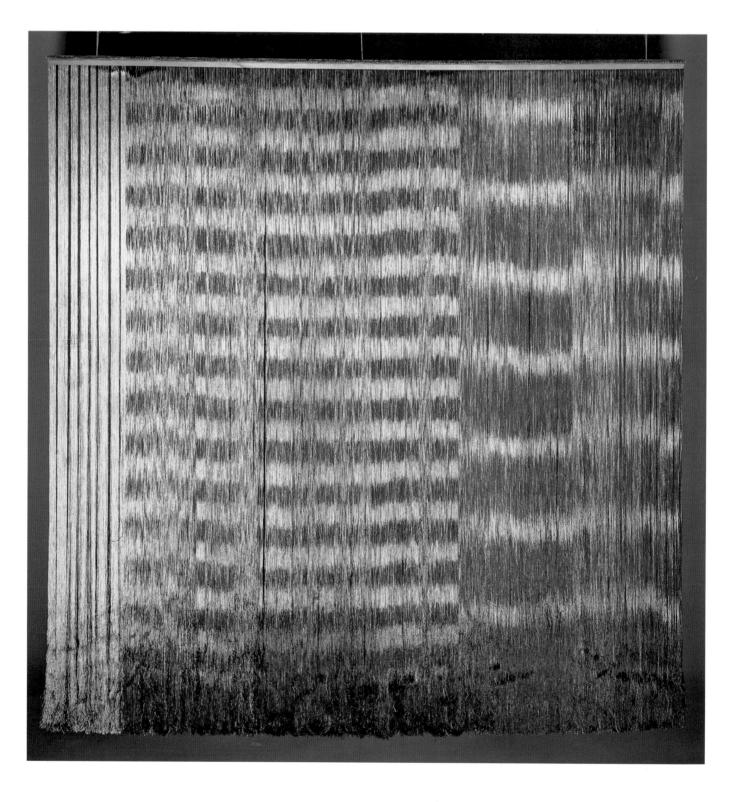

above:

Puziloi

1988

viscose, painted

200 x 200cm

right:

Markatsin

1998

viscose, painted

180 x 180cm

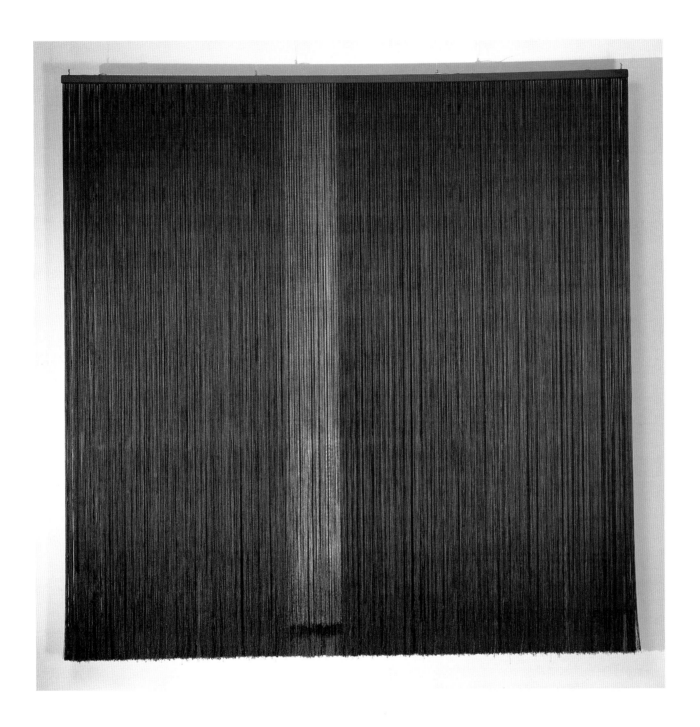

Bundling 50 painted threads together, considering their order in the composition and tying them to the frame – one work may require over 3,000 knots and up to 30 miles of viscose.

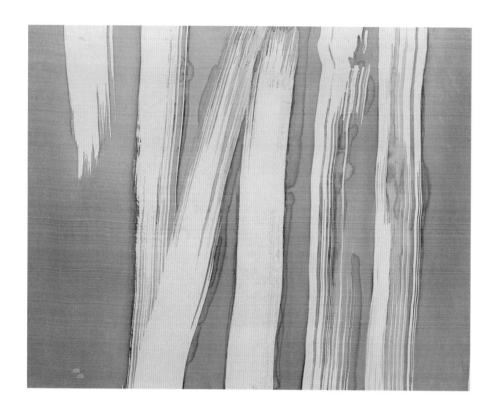

Silk painting
1982
silk, painted
40 x 50cm

The work is achieved in several stages: sketching, rolling thread, warping, spreading, painting, rinsing, drying, disentangling; then bundling 50 painted threads together, considering their order in the composition and tying them to the frame – one work may require over 3,000 knots and up to 30 miles of viscose. I often have help from an assistant for this work, and it is helpful for me to have some feedback from them. Viscose is rewarding to dye and it hangs beautifully. It is shiny and reflects light, ideal when striving for depth and vividness of colour.

Sometimes these paintings might evoke associations of nature, where their horizontal emphasis presents an image of landscape. That's what appeals to me about textiles: they can be both material and immaterial at the same time. They are real and touchable. You might describe them as 'slow' as they convey a sense of time. Actually, their slowness, in the practical sense, can be agonising for the maker who wants to do so much and actually achieves so little.

I take inspiration from the material itself. The vertical threads have their own natural rhythm complemented by the horizontal patterns. Like a weave, the pieces are based on vertical and horizontal elements. Though the working field is free to be painted, I mostly stick to horizontal stripes. It could be the influence of my weaving heritage, or it could be caused by my need for harmony – or perhaps it is a part of my own 'language'.

Elementary folk art and the work of many painters are my greatest sources of inspiration. In nature, I find myself almost unconsciously observing striped patterns, whether of animal fur, feathers, or butterfly wings. I enjoy gazing at meadows in their constant metamorphosis, under the influence of the seasons, the sun, clouds and wind.

In nature, I find myself almost unconsciously observing striped patterns, whether of animal fur, feathers, or butterfly wings. I enjoy gazing at meadows in their constant metamorphosis, under the influence of the seasons, the sun, clouds and wind.

right:
Crex Crex
1995
viscose, painted
200 x 50cm

far right:
Cock's Step
1995
viscose, painted
200 x 50cm

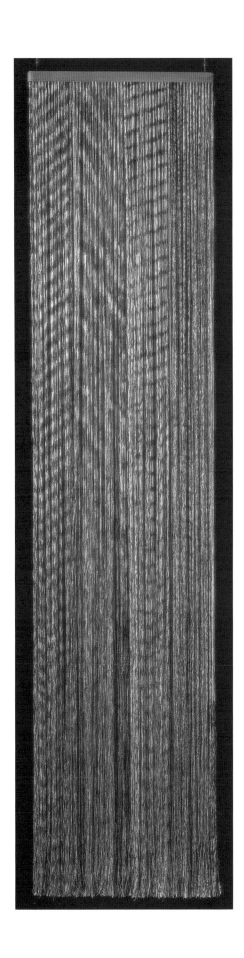
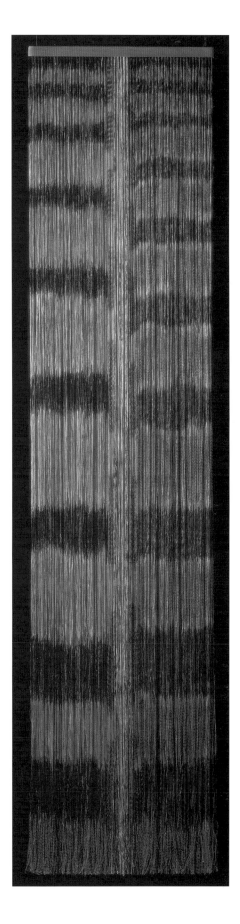

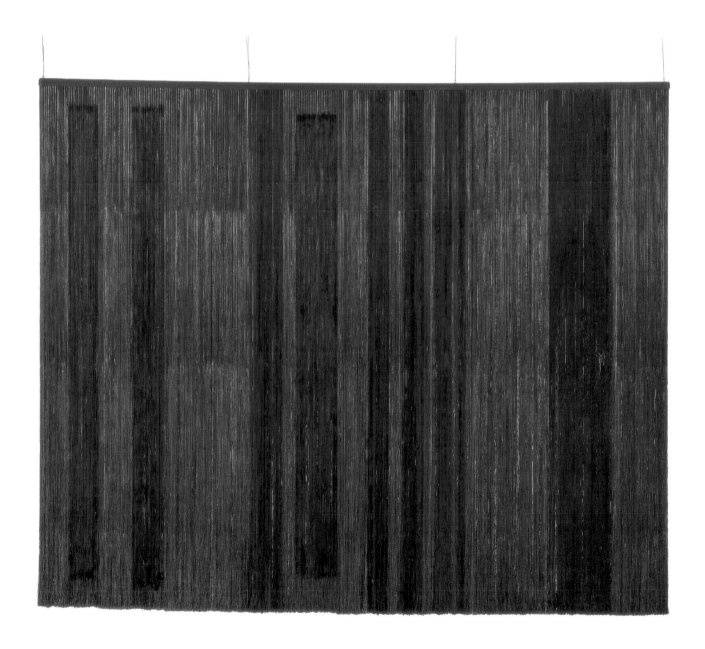

Iquique
1997
viscose, painted
180 x 200cm

Born 1943, Oulu, Finland
Atelier Helsinki, Finland
 www.inhouse.fi

Education and Awards
1964-1974	University of Arts and Design, Helsinki
1992	Textile Artist of the Year 1992
1993-	State 15 Year Grant
2002	University of Arts and Design, Helsinki (Master of Arts)

Exhibitions
2004	11th International Triennial of Tapestry, Lódz, Poland
2003	Kloster Schloss Bentlage (solo), Rheine, Germany
2002	Masterpieces, Palazzo Bricherasio, Torino
2000	Norrút, Art Museum ASÍ (tour), Reykjavik
1999	Galleri Inger Molin, Stockholm
1998	Museum Schloss Rheydt (solo), Mönchengladbach, Germany
	Art Gallery of Western Australia, Perth
1996	Medicine Hat Museum and Art Gallery (solo), Canada
	Hordaland Kunstnersentrum, Bergen (solo), Norway
1992	15th International Lausanne Biennial, Switzerland

Collections

American Craft Museum, New York
City of Espoo, City of Helsinki, City of Lahti, City of Skellefteå
Design Museum, Helsinki
European Parliament, Strasburg
EU Court of Justice, Luxemburg
International Museum of Applied Art, Turin, Italy
Jenny and Antti Wihuri Foundation, Rovaniemi Art Museum
Mint Museum of Art + Design, Charlotte NC, USA
State of Sweden
Umeå University
Various Finnish embassies around the world

Scandinavia volume 2

in preparation | summer 2005 | ISBN 1 902015 05 3

Artists including:

Nina Hart (Denmark)

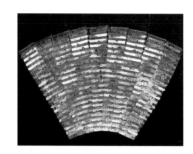

Agneta Hobin (Finland)

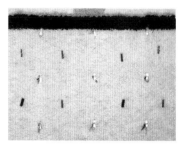

Maija Lavonen (Finland)

Kirsten Nissen (Denmark)

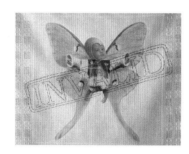

Silja Puranen (Finland)

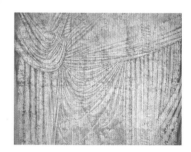

Bente Saetrang (Norway)

Ingunn Skogholt (Norway)

Grethe Wittrock (Denmark)